James McNeill Whistler

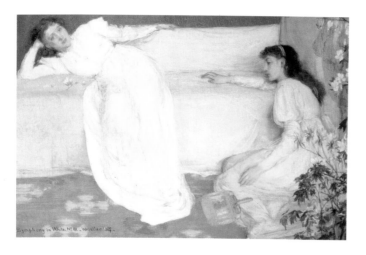

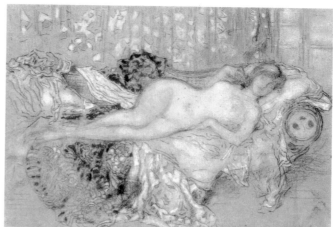

© 2005 Confidential Concepts, worldwide, USA
© 2005 Sirrocco, London, (English version)

Published in 2005 by Grange Books
an imprint of Grange Books Plc
The Grange Kingsnorth Industrial Estate
Hoo, nr Rochester Kent ME3 9ND
www.Grangebooks.co.uk

ISBN 1-84013-659-6

Printed in China

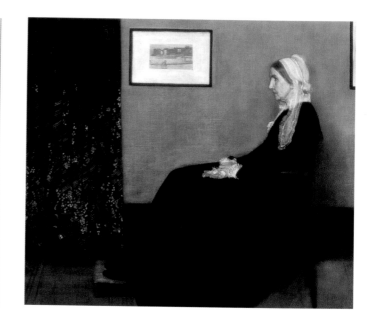

James McNeill Whistler

Grange
BOOKS

Whistler suddenly shot to fame like a meteor at a crucial moment in the history of art, a field in which he was a pioneer. Like the Impressionists, with whom he sided, he wanted to impose his own ideas. Whistler's work can be divided into four periods. The first was a research period in which the artist was influenced by the realism of Gustave Courbet and by Japanese art.

Whistler then discovered his own originality in the *Nocturnes* and the *Cremorne Gardens* series, thereby coming into conflict with the academics who wanted a work of art to tell a story. When he painted the portrait of his mother, Whistler entitled it *Arrangement in Gray and Black* and this is symbolic of his aesthetic theories. When painting the *Cremorne Pleasure Gardens* it was not to depict identifiable figures, as did Renoir in his work on similar themes, but to capture an atmosphere. He loved the mists that hovered over the banks of the Thames, the pale lights, the factory chimneys which at night turned into magical minarets. Night redrew landscapes, effacing the details. This was the period in which he became a precursor and adventurer in art; his work, which verged on abstraction, shocked his contemporaries.

The third period is dominated by the full-length portraits which brought him his fame. He was able to imbue this traditional genre with his profound originality. He tried to capture part of the souls of his models and placed the characters in their natural habitat. This gave his models a strange presence so that they seem about to walk out of the picture to come amongst us. By extracting the poetic substance from individuals he created portraits described as mediums by his contemporaries, and which were the inspiration for Oscar Wilde's *The Picture of Dorian Gray*.

Toward the end of his life, the artist began painting landscapes and portraits in the classical tradition, strongly influenced by Velasquez. Whistler proved to be extremely rigorous in constantly ensuring that his paintings coincided with his theories. He never hesitated in crossing swords with the most famous art theoreticians of his day. His personality, his outbursts, and his elegance were a perfect focus for curiosity and admiration. A close friend of Stéphane Mallarmé, admired by Marcel Proust who rendered homage to him in *A La Recherche du Temps Perdu*, a provocative dandy, a prickly socialite, a demanding artist, he was a daring innovator.

1. ***James A. McNeill Whistler***,
 after a drypoint by
 Paul-César Helleu.

2. **Wapping**. 1860-1864.
 28 x 39 in.
 (71.1 x 101.6 cm).
 Signed and dated
 Whistler 1861. National
 Gallery of Art, John
 Hay Whitney
 Collection, Washington.

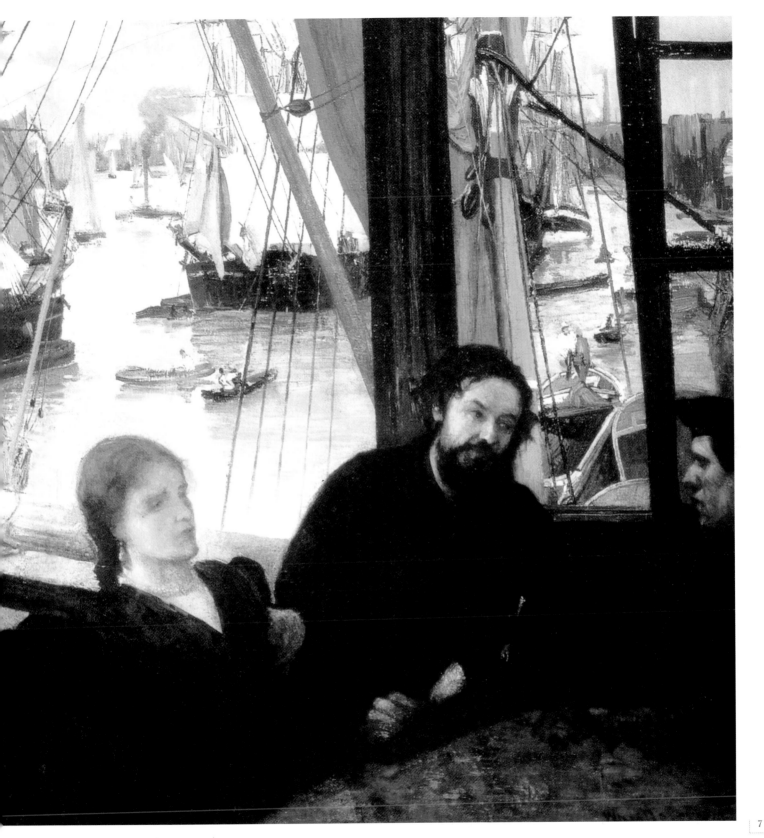

Born Under a Wandering Star (1834-1863)

James Abbott Whistler was born on July 10, 1834, in Lowell, a little town in Massachusetts. James's father was a graduate of West Point Military Academy. He took Anna Mathilda McNeill as his second wife. Whistler was a railroad engineer in Lowell, and this is where James and his two brothers were born. In 1842, Nicholas I, Tsar of Russia, chose John Whistler to build him a railroad from St. Petersburg to Moscow and Major Whistler left for Russia. A year after her husband's departure, Mrs. Whistler and her children took the same route for St. Petersburg. During the trip, the youngest son fell gravely ill and died. James was nine years old at the time. Despite his strict upbringing, the child encountered many of the influences which were to shape his future career as an artist. The Scottish artist, Sir William Allen, was a frequent visitor of the Whistlers, and James greatly enjoyed the conversations which he heard in the drawing-room. Once the children were in bed, the painter took Mrs. Whistler apart and confided to her, "Your son has an exceptional talent." From these first attempts there remains a portrait of his aunt, Alicia McNeill. James spent his time drawing and leafing through the large volume of engravings by Hogarth, whom he would always consider to be England's greatest artist.

A cholera epidemic had broken out in St. Petersburg. Mrs. Whistler had to leave hurriedly for England with her children. On November 9, 1849, Major Whistler died without ever seeing his family again and the repercussions of his demise on the family finances forced them to go back to Connecticut. James was now a teenager and despite his mother's strictness, his personality began to show through and his opinions started to take shape. The Whistlers and the McNeills both had a tradition of military men in the family. James's mother enrolled him at the greatest military academy in the United States, West Point, which he entered in 1851.

3. *At the Piano*.
1858-1859.
26 x 36 in.
(67 x 91 cm).
Taft Museum,
Cincinnati, Ohio.

Even in his first year, his examination results were revealing: he was first in drawing, but thirty-ninth out of forty-three in philosophy and at the bottom in chemistry. He took little notice of the academy's discipline and the disapproval of his lateness and his careless dress. Guided, like his fellows, by a sense of honor, James could not prevent himself from revolting internally against its traditions, despite his respect for certain ideas of chivalry. The young man was not cut out for a military career, being incapable of submitting himself to the strict discipline. He was informed of his dismissal in June 1854.

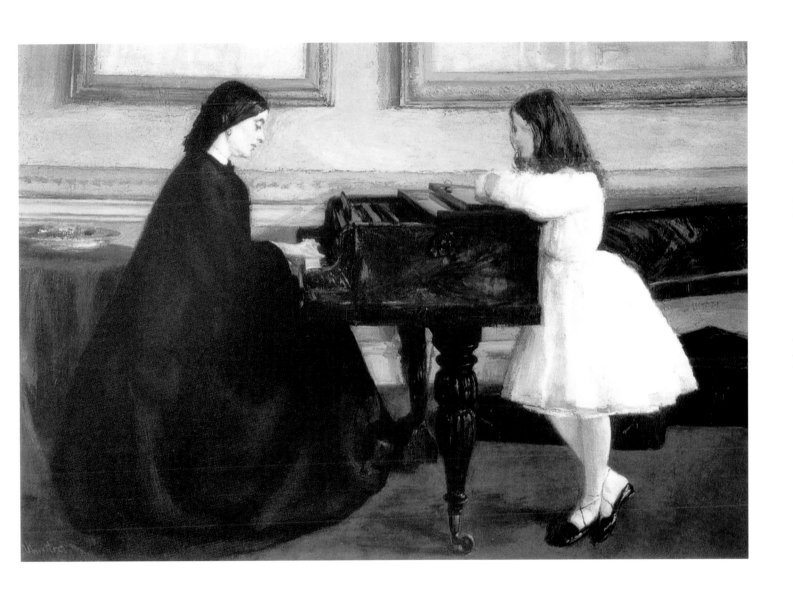

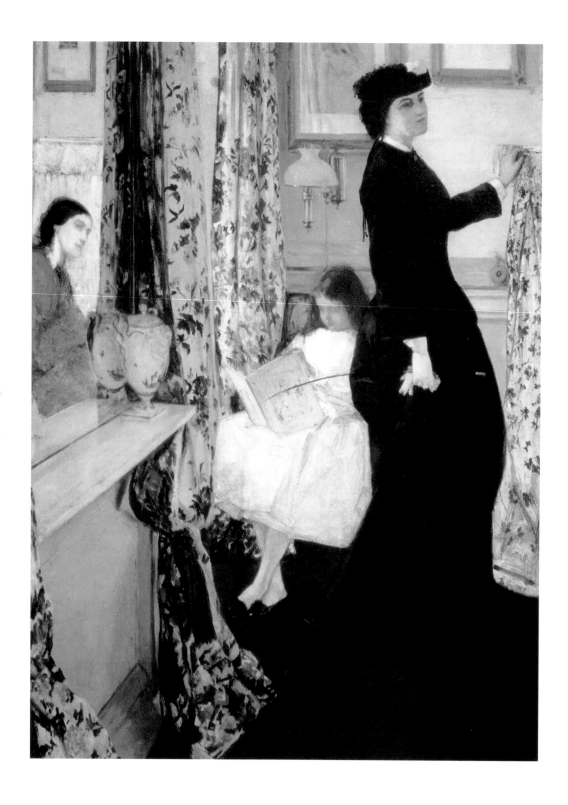

After leaving the academy, Whistler was apprenticed at a locomotive factory in Baltimore and spent his days wandering around the workshops and offices. Soon, the boredom became intolerable and Whistler left Baltimore. Here again, he found he disliked office routine and did his work without enthusiasm. Whistler led a very active social life. He was often to be seen at receptions, dressed in the latest fashion. The young James Whistler was passionate about drawing and painting and despised anything not directly related to it. Whistler was regarded as something of a practical joker. James became very bored in the Geodetic Coastal Survey and resigned in February 1855. Yet, as in the case of West Point, the few months he had spent at the office were of great importance for his career. In fact, he had learned how to make etchings, a technique in which he would come to excel.

As soon as Whistler came of age, he decided to go to Paris. The artist Gustave Courbet had been refused an exhibit at the official exhibition and launched his first manifesto on behalf of the Realist School of painting. Whistler became friendly with the artist and thus began a relationship with the realists. This is how he met Fantin-Latour and Edgar Degas. On November 9, 1855, the young engineer enrolled at the Ecole des Arts Décoratifs (School of Applied Arts) and became a pupil of Charles Gleyre in 1856. The master welcomed into his studio those who wanted to escape the influence of classes in which the teaching was too classical. Gleyre's teaching was original, based as it were on personal theories which horrified the academic painters. He recommended preparing color on the palette before beginning to paint. Whistler adopted this technique which had the advantage of releasing the painter from constraints, leaving him completely free to work on the modeling.

Whistler did not work very hard and enjoyed himself greatly. He moved to a little hotel and would go out with his sketchpad to make quick sketches of scenes from everyday life. Whistler perfected his technique, especially the effects of light at night-time, working on the basis of one tone, one color, and its variants. He respected the tradition of painting, studied the techniques of the Old Masters and, like his fellow students, went to the Louvre to copy the paintings. He admired Rembrandt and Velasquez. His painting *At the Piano* (which he used to call "The piano picture") was submitted to the Salon of 1859 but was rejected since it was judged to be too "original." This painting revealed an early desire for unity and a harmonious distribution of color. Some of the rejected paintings were exhibited at the Atelier Bonvin, and on this occasion, Whistler was congratulated by Courbet.

4. *Harmony in Green and Rose: The Music Room*. 1860-1861. 37 5/8 x 27 7/8 in. (95.5 x 70.8 cm). Freer Gallery of Art, Smithsonian Institution, Washington.

In 1859, Whistler decided to move to London and would never again live in France, although he would visit several times. In the four years between 1859 and 1863, Whistler stopped being a "rebel" and turned into a well-known artist. Whistler had adopted a very unusual style of dress. People would turn to stare at him as he passed in order to get a good look at this outrageous dandy.

The years 1860 through 1870 were dominated by his triumph at the British Royal Academy. Whistler submitted *At the Piano* and five etchings to this institution, which was going through a strong pre-Raphaelite phase. The paintings were accepted and the critics received them quite favorably. The painter took his first step on the ladder of fame.

In 1863, the artist worked hard on a canvas which he called *Wapping*. The painting was exhibited at the Royal Academy in 1864 and at the Universal Exhibition in Paris in 1867. It shows three people, a workman, Legros and Jo Heffernan, his model at that time. Whistler worked on a drypoint entitled *Annie Haden*, for which the artist's niece posed wearing a crinoline and a fashionable hat.

A society of engravers ordered two etchings to illustrate a book of poems. The work involved was considerable; Whistler claimed to have spent three weeks on each of them. In 1861, he sent *La Mère Gérard* to the Royal Academy and was acclaimed by the press. In the summer, he sailed to the coast of Brittany in France and painted some realistic landscapes.

Returning to Paris with Jo Heffernan, Whistler rented a studio on the Boulevard des Batignolles to paint a life-size, full-length portrait of her. She is dressed in white, with a white curtain behind her and a white flower in her hand; her arms are by her sides. The painting is entitled *The White Girl*. Whistler was beginning to disassociate himself from "this damned realism," as he called it. The Royal Academy refused to exhibit *The White Girl*, which was judged to be too original.

5. ***Blue and Silver; Blue Wave, Biarritz***. 1862. 24 x 34 in. (62.2 x 86.4 cm). Hill-Stead Museum, Farmington, Connecticut.

The subject disconcerted his contemporaries as well as his treatment of it, with its white on white. Whistler was furious and this marked the beginning of his lengthy crusade against the art critics in the press. A Bohemian, though an elitist, he tried to serve as a mirror for the aristocracy and side with them in their liberation from bourgeois convention.

All the great themes beloved by Whistler are present in *The White Girl* - the purified shapes, the play of colors, tone upon tone. Despite his London disappointment with *The White Girl*, he decided to exhibit it in Paris. Unfortunately, that year the Salon rejected a whole generation of painters, including Manet and Whistler. Napoleon III decided to inaugurate a Salon des Refusés, which was held at the Palace of Industry, the same place as the official Salon. The opening on May 16, 1863, owed much of its success to the scandal which preceded its announcement. Later, Whistler would re-christen the portrait *Symphony in White*. The painting was the event of the exhibition, becoming even more notorious than Manet's *Déjeuner sur l'Herbe*. After the Parisian triumph came new honors from England and Holland. The etchings exhibited at The Hague won him a gold medal, the first in his career, and the British Museum bought twelve of his engravings. Whistler decided to return to London. His paintings were not devoted to particular themes and Whistler seemed to be totally original, but he had won the admiration of his fellow artists and of connoisseurs.

Japanese Influence, *The Mists of Valparaiso, Nocturnes on the Thames* and *Cremorne Gardens* (1863-1874)

At the age of twenty-nine, Whistler moved to London. From his bedroom window, Whistler could contemplate Battersea Bridge and at night he could see the lights of the Cremorne Gardens. On a river barge, at dusk or dawn, Whistler produced sketches that would be finished from memory once the artist was again on terra firma.

Japanese art had begun to be popular in England and France. James decorated the walls of his house with oriental fans against matching backgrounds; he favored a lack of elaborate ornamentation at a time when other artists favored a riot of bric-a-brac. Whistler's re-interpretation of Japanese art made him consider he was taking the right direction by abandoning Courbet's realism. He chose simple subjects, was inspired by the white spaces left in woodcuts and tried to reproduce the effects of colors that had hitherto been unexplored. In this spirit he created the paintings *Lange Lijzen, The Gold Screen, The Balcony*, and *La Princesse du Pays de Porcelaine*. For him Japanese art was a mere pretext, a means to an end. The other paintings in the series have titles which reveal his true preoccupations, such as *Red and Rose, Caprice in Purple and Gold, Harmony in Green and Flesh Color*, and *Rose and Silver*. It was a good idea because a collector soon became interested in buying it if the painter were to agree to change his signature.

6. *Symphony in White, No. 1: The White Girl*. 1862. 86 x 43 in. (214.6 x 108 cm). Harris Whittemore Collection, National Gallery of Art, Washington.

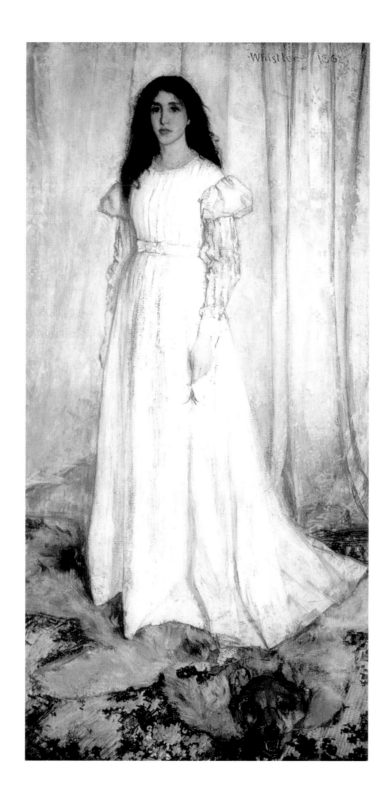

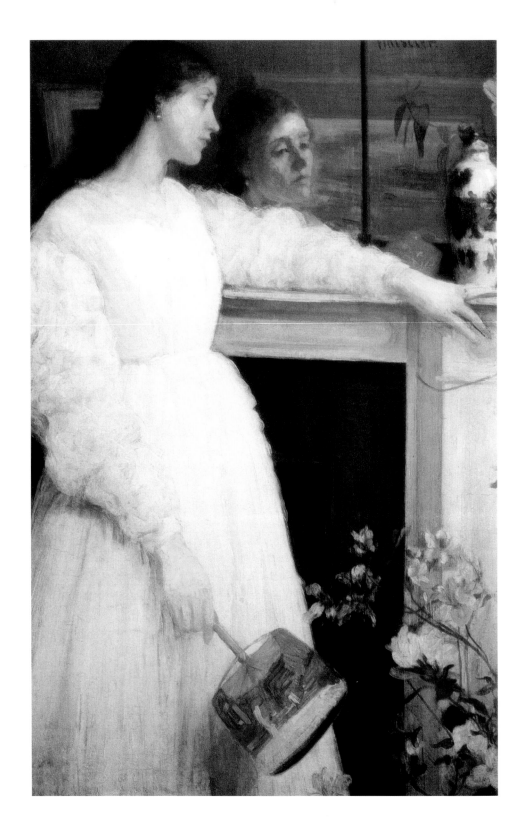

7. *Symphony in White,*
No. 2: The Little
White Girl. 1864.
29 7/8 x 20 in.
(76 x 51 cm).
Tate Gallery, London.

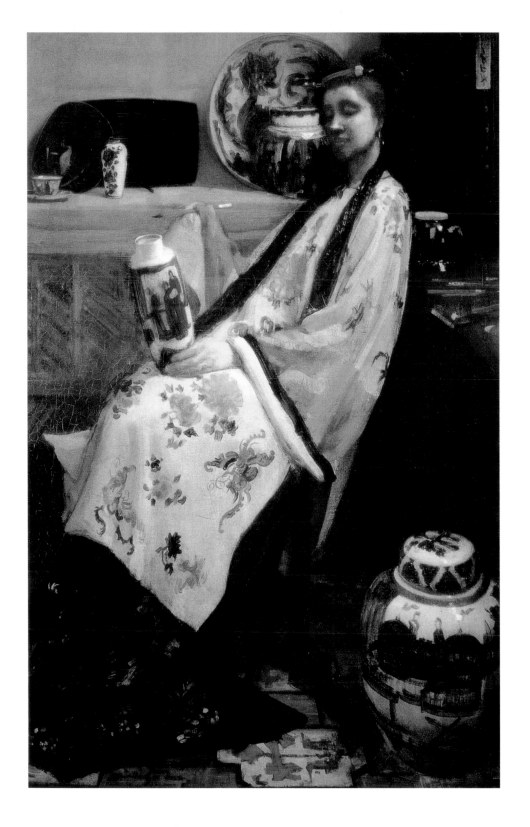

8. ***Purple and Rose: The Lange Lijzen of the Six Marks***. 1864. 35 7/8 x 22 1/8 in. (91 x 56 cm). The John G. Johnson Collection, Philadelphia Museum of Art.

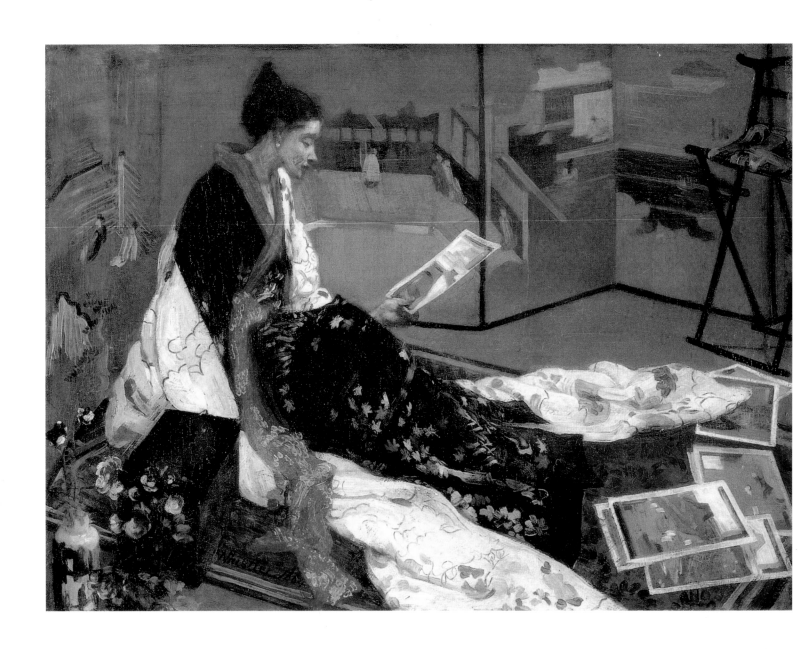

The artist refused and drew a lesson from this episode by modifying his signature. Henceforward, the signature would consist of his initials inside a cartouche which would later be changed to a butterfly. This insect was not chosen by chance and was very carefully positioned from the first rough sketches so as to balance with the composition of the painting.

In 1865, he exhibited *The Little White Girl*. Jo Heffernan, his favorite model, is shown leaning against a mantel, holding a fan with her face reflected in the mirror over the mantel. The painting was considered by numerous contemporary artists as one of the most important of the century.

In early 1866, Whistler decided to take a trip to Valparaiso, Chile. The trip was noteworthy for an earthquake and the shelling of Valparaiso by the Spanish navy. The town, which stretches around a bay, was lit up by the light of the setting sun and the explosions of the shells raining down upon the city and ships caught in the sea-roads. This unique spectacle first gave Whistler the idea of painting at night, and he produced three views of the port.

In January 1867, the French Gallery in London exhibited two of the paintings Whistler had produced during his trip. The first, a very wide canvas, depicted a view of the port of Valparaiso after the sun had set. Another view of Valparaiso exhibited was in fact one of the earliest paintings in the *Nocturnes* series, and he would later rename it *Nocturne in Blue and Gold: Valparaiso*. Daylight still illuminates the painting, but it is already foggy and silvery and the moon is out. The spatial relationships are ambiguous and details disappear to be replaced by outlines of the main shapes, creating a special atmosphere which would be impossible to conceive of during the day. The ships cease to be ships and melt into a blue haze. Painted by daylight, the three planes of the picture would have separated into the embankment, the sea and the sky. Whistler explained his predilection for the night by asserting that he awaited the moment at which nature redesigns itself.

In that same year, *At the Piano* was accepted by the jury of the Paris Salon which had rejected it eight years earlier. Musical terminology was often used by artists of the period. Whistler judged it particularly appropriate for describing his paintings. He knows now that art does not consist in reproducing what one sees, but in using the materials offered by nature in order to create something new.

9. *Caprice in Purple and Gold: The Golden Screen*. 1864. 50.2 x 68.7 cm. Freer Gallery of Art, Smithsonian Institution, Washington.

He often speaks of stylization, harmony and symmetry. Whistler gradually embraced what would become one of his main ideas in painting, namely that a dominant color must always be used to determine the tonality of the whole.

He proposed painting six canvases, each one named for a symphony of color. These Six Projects show to what extent Whistler was working around a single theme, symphonic and musical variations of color.

He was inspired by writers, as well as by composers such as Claude Debussy, Reynaldo Hahn, Camille Saint-Saëns, and Maurice Ravel. Discouraged by the public's attitude toward his painting, Whistler gained fame through his engravings. He was patronized by Mr. Leathart and Mr. Leyland (calling the latter "the Medici of Liverpool"), Mr. Hurt, Mr. Alexander, Mr. Rawlinson, Mr. Anderson Rose, and Messrs. Jameson, Potter and Chapman.

The Japanese theory of drawing, which he adapted, enabled him to attain a certain form of purity by eliminating numerous elements of detail and revive classic techniques from western painting. Yet to him, nowhere did the night seem as beautiful, even in Valparaiso or Venice, as it did in London where the plays of diurnal light on the Thames redesigned space and form. The eye became lost, then adapted to a new vision of the world thus transformed. The English public, who were accustomed to painters' minute "realist" detail considered the *Nocturnes* as mere sketches lacking a subject, but in fact, these paintings were extremely difficult to design. The *Nocturnes* series represents the illustration of one of Whistler's favorite theories, "A work can only be successful if all trace of effort has disappeared." Twenty years later, the *Nocturnes* series would be recognized and celebrated. The painter confirmed that he did not want to paint the night, but to reproduce its effect.

10. ***Rose and Silver: La Princesse du Pays de Porcelaine.***
1863-1864.
78 x 45 in.
(199.2 x 114.8 cm).
Freer Gallery of Art, Smithsonian Institution, Washington.

Whistler would shape his paintbrushes after having used a candle flame to soften the glue which held the bristles. He mixed his colors using turpentine and linseed oil diluted in a mixture of copal and mastic. He would arrange his colors on a rectangular, 24 x 36 inch palette, with grooves to hold the paint tubes and paintbrushes. This palette constituted the top of a table containing a large number of tiny drawers. The *Nocturnes* were painted on very absorbent canvas or wood panels. In these paintings, the dominant color is blue, so the artist painted on a red ground or used a piece of mahogany. The blues placed over the red thus gained in intensity. In other paintings, especially those featuring fireworks, the background is coated with a warm black.

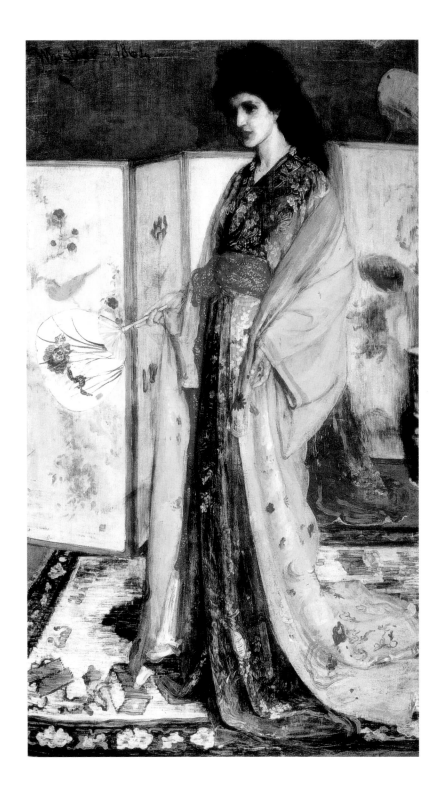

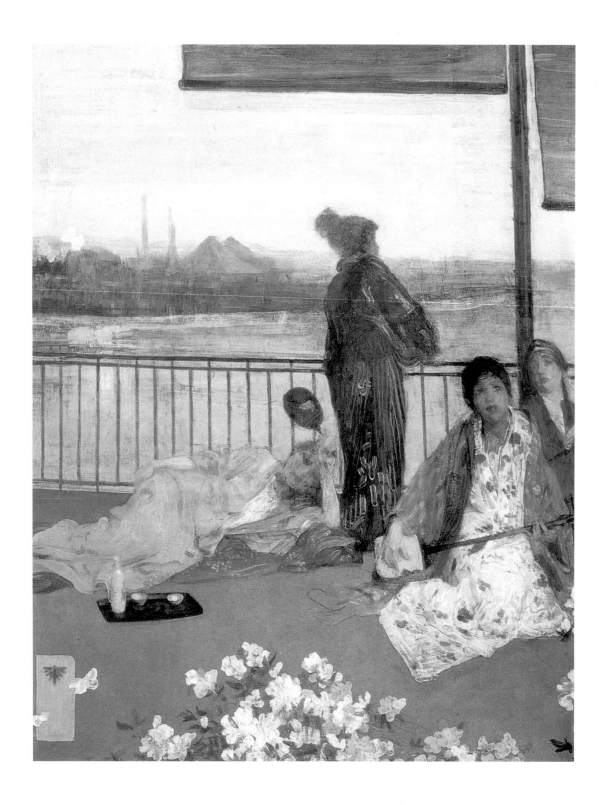

This prior choice of medium made it possible for him not to have to overload the canvas at a later stage. The sky and the water were created with a few strokes of the paintbrush. Testing for the right tint took a long time, but once the correct color had been obtained, the artist was able to complete a *Nocturne* in a single day.

The complete series of the *Nocturnes* covered the period from 1866 through 1877. In the case of the painting *The Solent*, Whistler created an almost monochrome composition. It is almost impossible to tell where the sky ends and the water begins. The painter is obsessed by the idea of using the smallest number of decisive strokes. This is a concept drawn from the oriental masters. *Nocturne in Black and Gold: Entrance to Southampton Water* (1872-1874) helps to reveal the secret of Whistler's compositions.

The outlines are vague and constantly changing. They alter ceaselessly as the eye moves over the picture discovering new aspects. The result was confusing for an unaccustomed public and in two exhibitions a *Nocturne* was hung upside down, not intentionally but simply in error.

Nighttime, more than daytime, gave Whistler the opportunity to test areas of light and shade, of colors designed like disembodied forms playing the role of abstract elements. The night itself seems to denude shapes of their literal significance and deprive them of detail. Some of the *Nocturnes* verge on the abstract. When one considers the English mentality of the period, the *Nocturnes* series was a rare example of audacity and a man of Whistler's temperament was needed to dare to do it.

The methods used by Whistler to paint the *Nocturnes* were as unconventional as the paintings themselves. A craftsman who printed many of Whistler's lithographs tells of a walk with the artist, when "he stopped suddenly, pointed at a group of distant buildings, an old ruin at the corner of a street, the windows and storefronts showing their golden lights through the foggy dusk. Whistler looked at them and since he had nothing with which to make notes or sketches, I offered him my notebook. He replied, 'No, no, don't move.'

After stopping for a long time, he stepped back, turned, and took a few paces back; then turning his back on the landscape which I was still looking at, he said to me, 'Now we'll see if I have learned it properly,' and gave me a complete description of the landscape just as one recites a poem that has been learned by heart."

11. *Variations in Flesh Color and Green: The Balcony*. 1867-1868. 24 1/8 x 19 in. (61.4 x 48.8 cm). Freer Gallery of Art, Smithsonian Institution, Washington.

The completion of the Nocturnes series with the depictions of the Cremorne Gardens enables us to understand how Whistler subscribed to the great tradition. Whistler paid a great deal of attention to these London pleasure gardens. He found a very special music in his night-time perambulations. Whistler attacked the general opinion of his day which took it for granted that the greatest accomplishment of art is to tell a story. He was particularly annoyed with art critics who in his view were responsible for the false notions which the public had of painting. Only the artist can read the secrets of nature and translate them into art. Like Baudelaire, James Whistler rejected Realism as a negation of the imagination. For him, the act of creation was more important than the subject chosen.

Cremorne Gardens was one of the last of the London pleasure gardens. It lay on the edge of town, a place to which Londoners used to come to amuse themselves. Seen though the veils of mist, the lights of the Gardens attracted Whistler into what he described as a "fairy-land" in the *Nocturne in Blue and Silver: Cremorne Lights*. The *Cremorne Gardens* series consists of seven oil paintings created between 1872 and 1877.

The parks had long been considered as the favourite place for the flourishing of fantasy and dreams. Whistler thought it important to depict the Cremorne Gardens in abstract terms because the traditional elements of the park no longer had much to offer the public. The weight of tradition is important in understanding the work. Whistler incorporated oriental techniques into *The Cremorne Gardens* series and Chinese motifs are numerous.

Whistler was attracted by the same centers of interest as his French contemporaries, namely, the popular singers and fireworks, which can also be seen in lithographs by Degas. Manet, Degas and Renoir painted numerous scenes in cafés and fashionable restaurants. Whistler happened to prefer the Gardens at night rather than the daylight scenes of the French artists. Whistler brings us into the gardens and through a dense and veiled atmosphere, the spectator shares the atmosphere of the place.

Although Whistler lacked the means to be independent, he maintained against everything his position regarding aestheticism. His elaborate dress, his spectacular lock of white hair, the elegant topcoat, his cane and the monocle he affected, even the succession of mistresses were part of a code of foppishness which belonged to the long tradition.

12. ***Nocturne in Blue and Gold: Valparaiso Bay.***
1866.
29 x 19 in.
(75.6 x 50.1 cm).
Freer Gallery of Art, Smithsonian Institution, Washington.

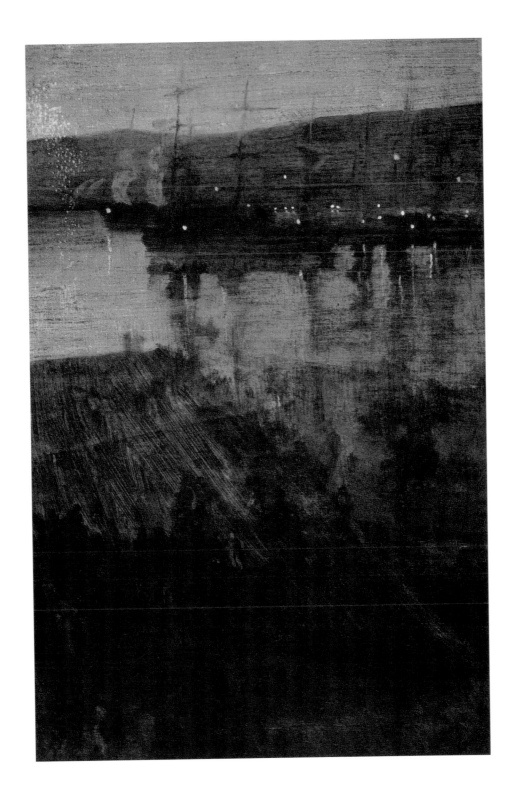

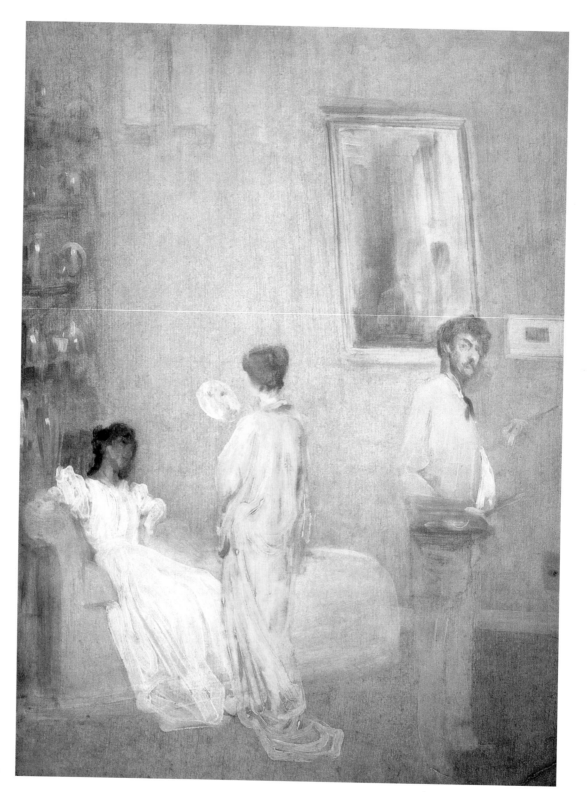

13. **Whistler in his Studio**. 1865-1866. 24 x 18 in. (62.9 x 47.6 cm). The Art Institute of Chicago.

14. **Crepuscule in Flesh Color and Green: Valparaiso**. 1866. 22 x 29 in. (58.4 x 75.9 cm). Tate Gallery, London.

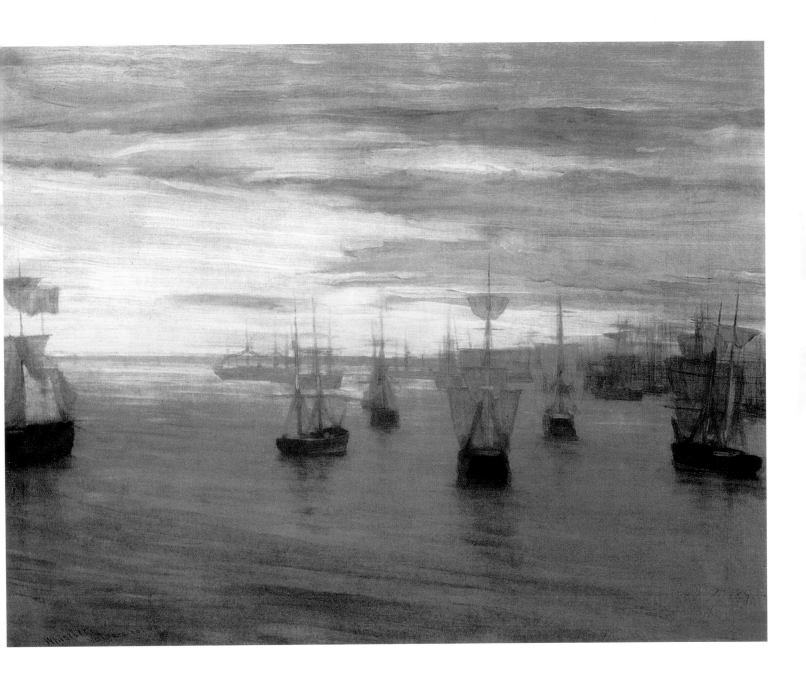

15. *Symphony in White,*
 No. 3. 1865-1867.
 20 x 30 1/8 in.
 (52 x 76.5 cm).
 The Barber Institute
 of Fine Arts,
 University of
 Birmingham, U.K.

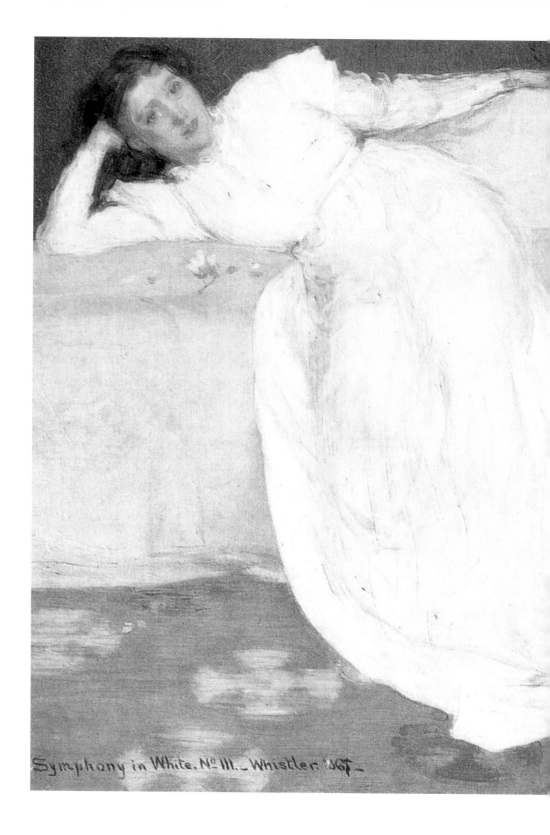

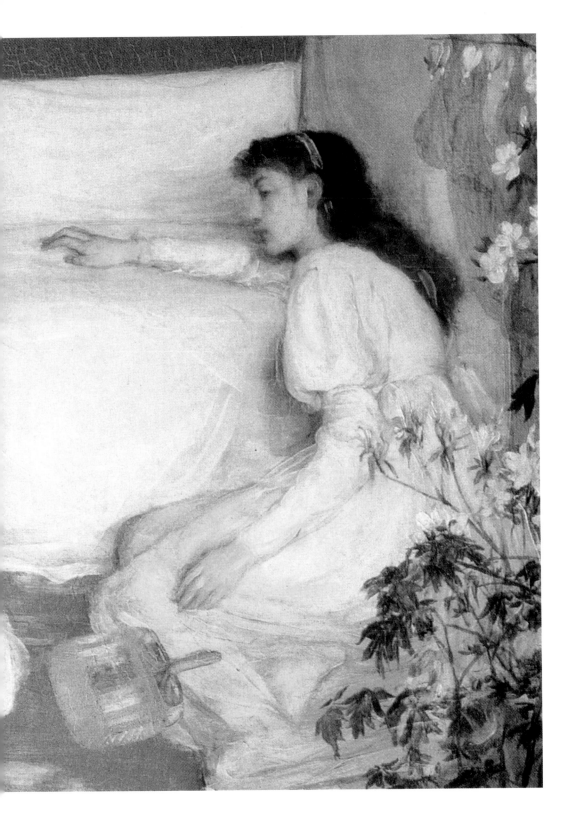

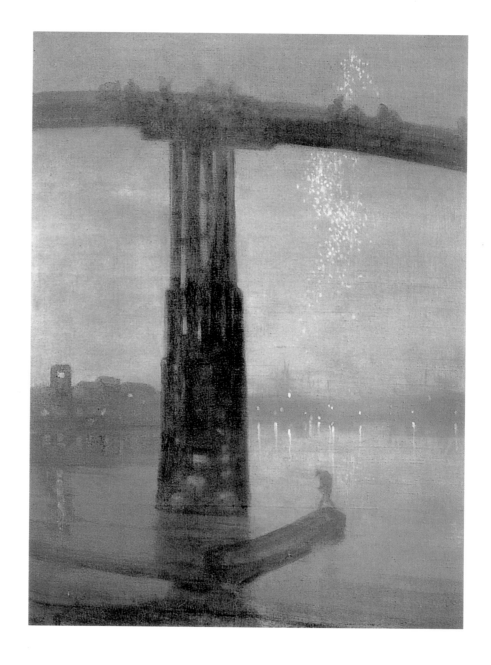

16. *Whistler*,
photographed by
Etienne Carjat, Paris.
1864.

17. *Nocturne: Blue and
Gold, Old Battersea
Bridge*. 1872-1873.
26 x 19 in.
(68.3 x 51.2 cm).
Tate Gallery, London.

18. *Arrangement in Grey
and Black: Portrait
of the Artist's Mother*.
1872.
57 7/8 x 64 5/8 in.
(145 x 164 cm).
Musée d'Orsay, Paris.

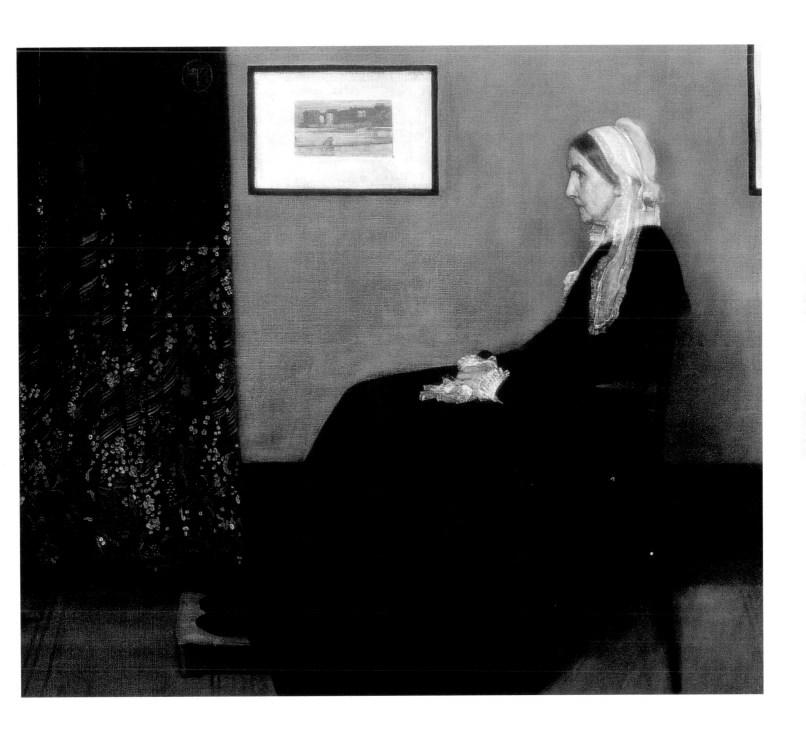

19. ***Nocturne in Blue and Silver: Battersea Reach***. 1872-1878. 15 4/5 x 25 1/5 in. (39.4 x 62.9 cm). Isabella Stewart Gardner Museum, Boston.

20. ***Nocturne in Black and Gold: The Fire Wheel***. 1872-1877. 21 x 29 in. (53.3 x 75.5 cm). Tate Gallery, London.

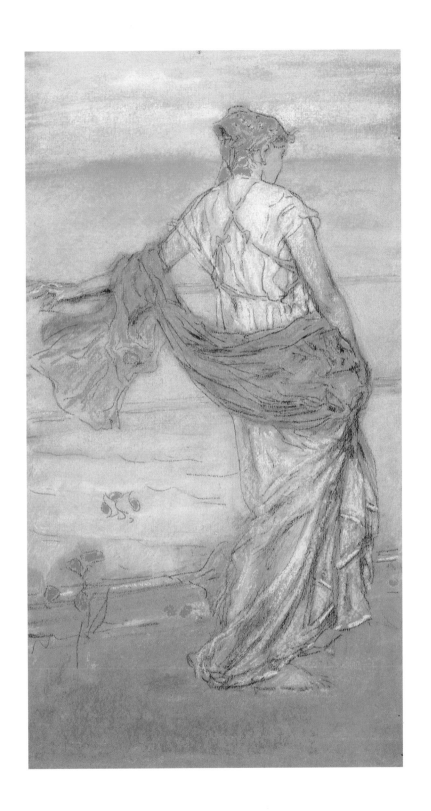

21. *Annabel Lee*. 1870.
12 4/5 x 7 in.
(32.5 x 17.8 cm)
Freer Gallery of Art,
Smithsonian
Institution,
Washington.

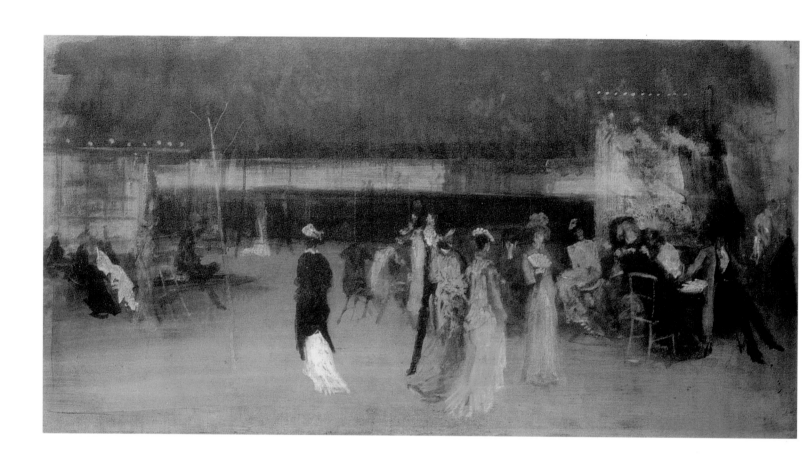

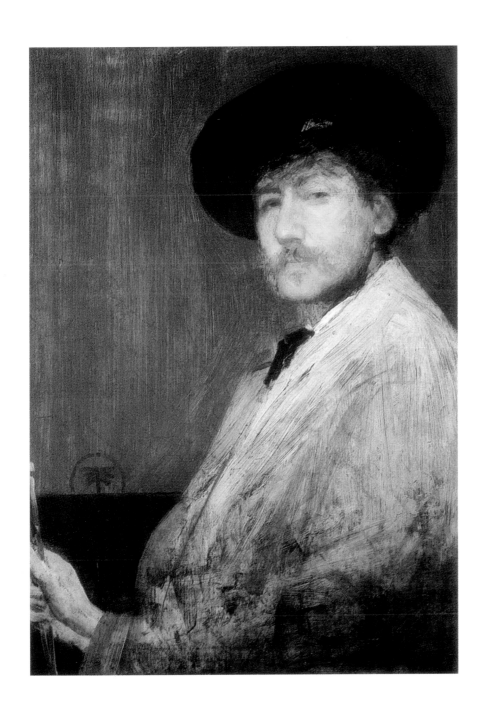

22. *Cremorne Gardens,
No. 2*. 1872-1877.
27 x 53 3/8 in.
(68.5 x 135.5 cm).
The Metropolitan
Museum of Art,
New York.

23. *Arrangement in
Grey: Portrait of the
Painter*. 1871-1873.
29 x 21 in.
(60.3 x 46.6 cm).
Detroit Institute of
Arts.

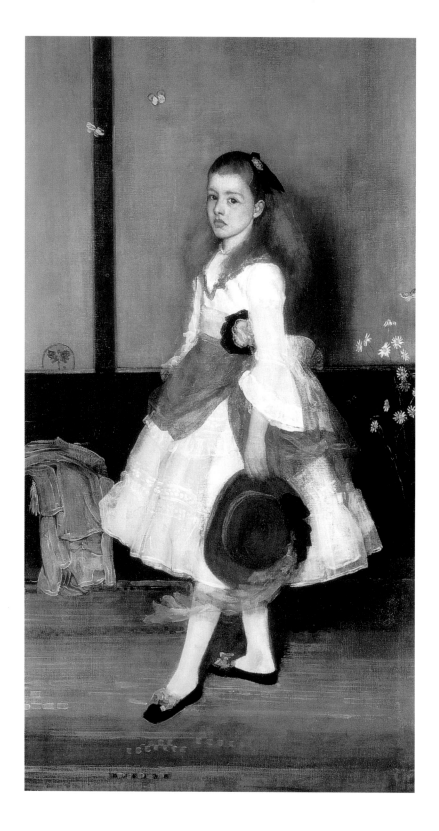

24. *Harmony in Grey and Green: Miss Cicely Alexander*. 1873.
86 x 39 in.
(218.4 x 99 cm).
Tate Gallery, London.

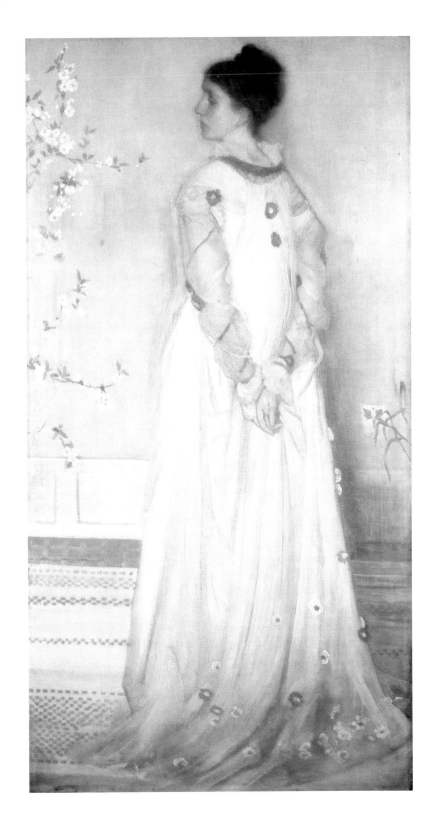

25. *Symphony in Flesh
Color and Pink:
Portrait of
Mrs. Frances Leyland*.
1873.
74 5/8 x 37 in.
(189.5 x 96 cm).
The Frick Collection,
New York.

For half a century, James Whistler continued to shock his critics and the artistic establishment even after a bitter struggle for acceptance by them. The *Cremorne* series was an anticipatory salvo, and an important one, against the Old Regime of Realism in painting. *The Falling Rocket* is much more than "a pot of paint flung in the public's face." It was an incendiary cocktail thrown by an aesthetic terrorist. Whistler ought perhaps to have supplied an explanatory text to his painting *The Falling Rocket*, in order to explain to his contemporaries the goals he was pursuing. But it might reasonably be supposed that they would not have reacted any better, the ideas of the painter being so far ahead of his time.

Harmony of Gold and Anger, The Peacock Room, The Ruskin Trial (1872-1880)

Whistler literally wore out his canvases by scraping and obliterating the same image dozens of times. The experimenter is destined to fail more often than to succeed. Whistler took a solitary road, defying any classification. He had shocked the world of painting and artistic concepts of the time and his influence was decisive. The emotive reaction provoked by his *Nocturnes*, his *Arrangements* and his *Variations* would stand out in history. The public and the critics were determined not to see further than the end of their nose. Whistler was merely an innovator but they considered him an eccentric. Obsessed by the need to destroy these failures, Whistler even hated looking at some of his work.

Toward the end of his life, he would bring to London the whole contents of his studio in Paris and would methodically burn the drawings and paintings which did not completely satisfy him. His working method, which consisted of painting and repainting until he was satisfied, was an agony of self-doubt. "I am so slow. When will I achieve a more rapid way of painting... I produce so little because I rub out so much." The technique of perfecting a painting is an attempt to resolve a seemingly insoluble problem, namely how to give a work created in several hours from life a deliberate essence. He forced himself to eliminate any trace of conflict visible on the canvas. One can sometimes see brush strokes, but one has no idea how many times they were erased and recommenced. His reputation is based mainly on the portraits and the *Nocturnes* which he produced in the years 1860-1870. The contemplation of a *Nocturne* or a portrait by Whistler requires one to "immerse" oneself in the painting.

26. *Photograph of John Ruskin*.

27. *Arrangement in Grey and Black, No. 2: Portrait of Thomas Carlyle*. 1872-1873. 67 3/8 x 56 in. (171 x 143.5 cm). Museum and Art Gallery, Glasgow.

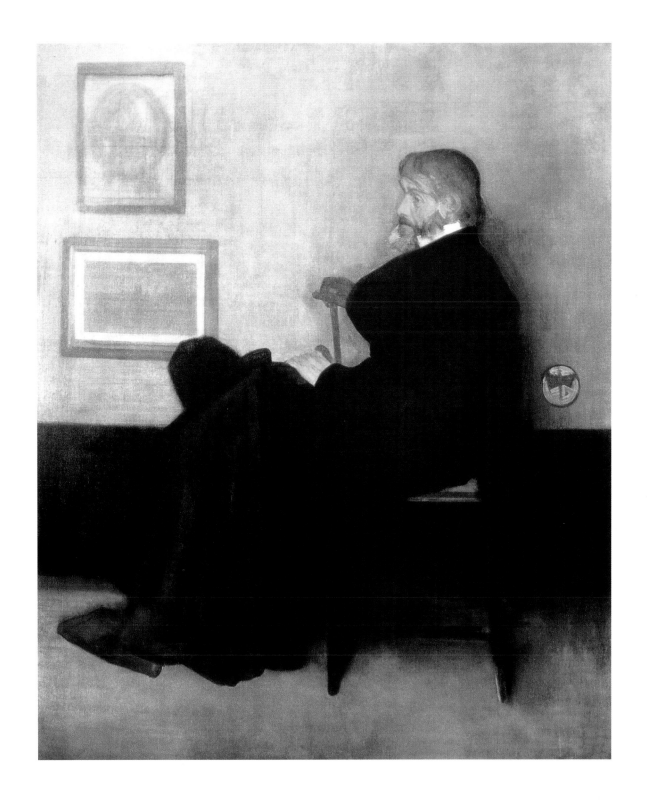

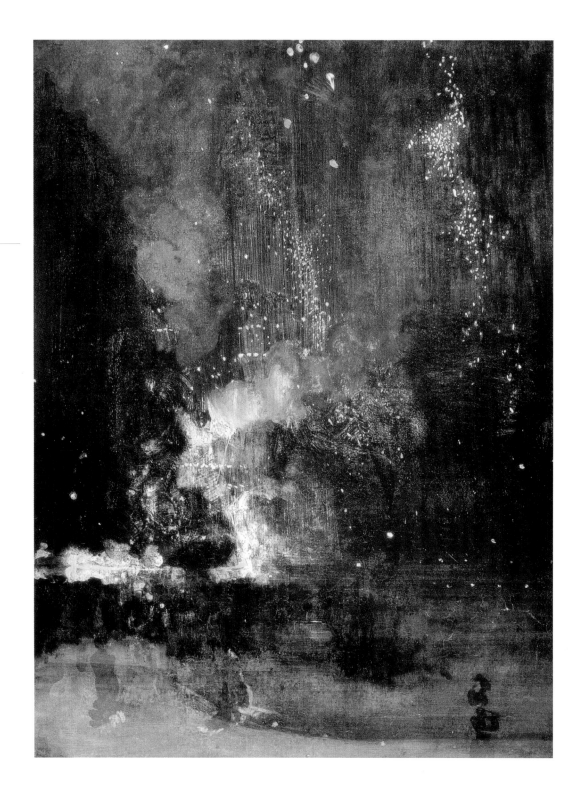

The subtleties will only become apparent to the spectator after attentive and prolonged contemplation. In Whistler's first exhibitions, the artist gained new notoriety because portraits such as these had never been seen before, the effect achieved was so different from that produced by other painters. A legend was born: Whistler was able to grasp the soul of his models which one can feel very clearly, ready to "emerge" from the picture to come and join us. Oscar Wilde was inspired by Whistler when he wrote his novel *The Picture of Dorian Gray*. Whistler wanted to succeed with portraits of mature people, without exotic touches. One of the first of these was that of his mother. Private commissions began to flow in.

In October 1874, he exhibited the *Nocturne in Blue and Gold No. 3* and *Nocturne in Black and Gold*: *The Falling Rocket* at the Dudley Gallery. Only the Belgian Alfred Stevens expressed a liking for these paintings. Apart from that, the event passed unnoticed. Whistler undertook new portraits but for the moment, our dandy was experiencing financial difficulties, and creditors threatened to seize them.

Rather than abandon his paintings, he slashed them with a knife. Whistler's attempts to exhibit his paintings nationally, in parallel with the Royal Academy had always failed hitherto. It was in reaction to the Academy's tyrannical attitude that Sir Coutts Lindsay founded the Grosvenor Gallery in 1877. The first exhibition included Whistler's *Nocturnes*, one of which was *The Falling Rocket*.

On July 2, as a result of this exhibition, John Ruskin, the passionate intellectual and foremost art critic, violently attacked Whistler in his magazine. Ruskin had been responsible for the success of the pre-Raphaelites and his convictions defended values which were moral as well as aesthetic. Ruskin claimed that nature was the only reason for art and a painter must reconstruct scenes from life as closely as possible.

When he saw the *Nocturnes*, he was filled with hatred of Whistler. Ruskin believed in his own infallible judgement. When he saw *The Falling Rocket*, he wrote, "I have seen and heard much of cockney impudence before now, but never expected to hear a coxcomb ask two hundred guineas for flinging a pot of paint into the public's face." The painter was outraged by the criticism, both as an artist and as a man, and he decided to take proceedings for libel against John Ruskin. There was an immediate consequence - the commissions stopped abruptly.

28. *Nocturne in Black and Gold: The Falling Rocket*. 1875. 23 x 18 3/8 in. (60.3 x 46.6 cm). Detroit Institute of Arts.

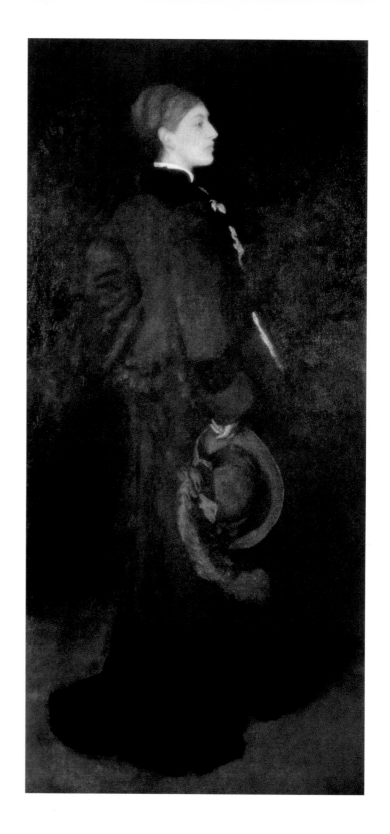

29. *Arrangement in Brown and Black: Portrait of Miss Rosa Corder*. 1875-1878. 75 1/8 x 35 3/8 in. (190.8 x 89.8 cm). The Frick Collection, New York.

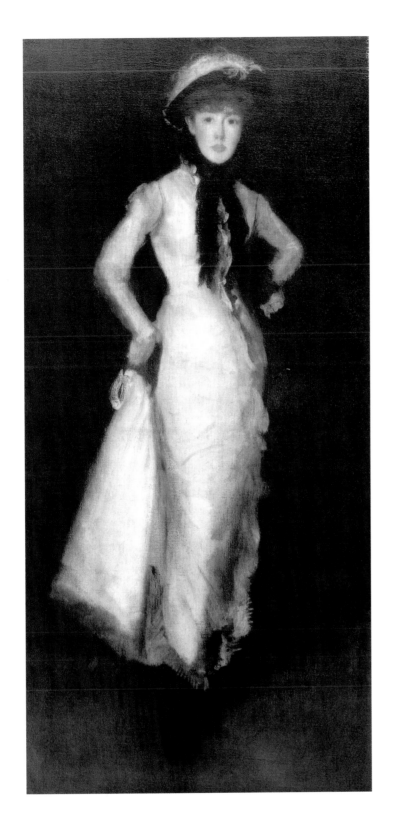

30. *Arrangement in White and Black: Portrait of Maud Franklin*. 1876. 75 x 34 in. (191.5 x 90.8 cm). Freer Gallery of Art, Smithsonian Institution, Washington.

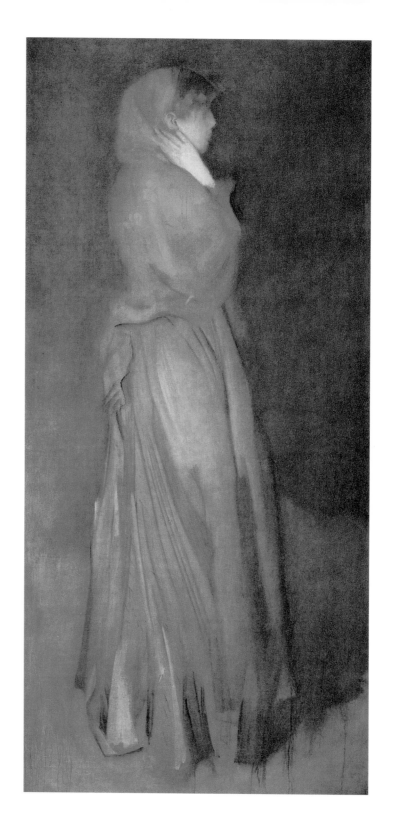

31. *Arrangement in Yellow and Gray: Effie Deans*. 1876. 77 x 37 1/8 in. (194 x 93 cm). Rijksmuseum, Amsterdam.

32. *Pink and Grey: Three Figures*. 1868. 57 x 73 in. (144.8 x 185.4 cm). Tate Gallery, London.

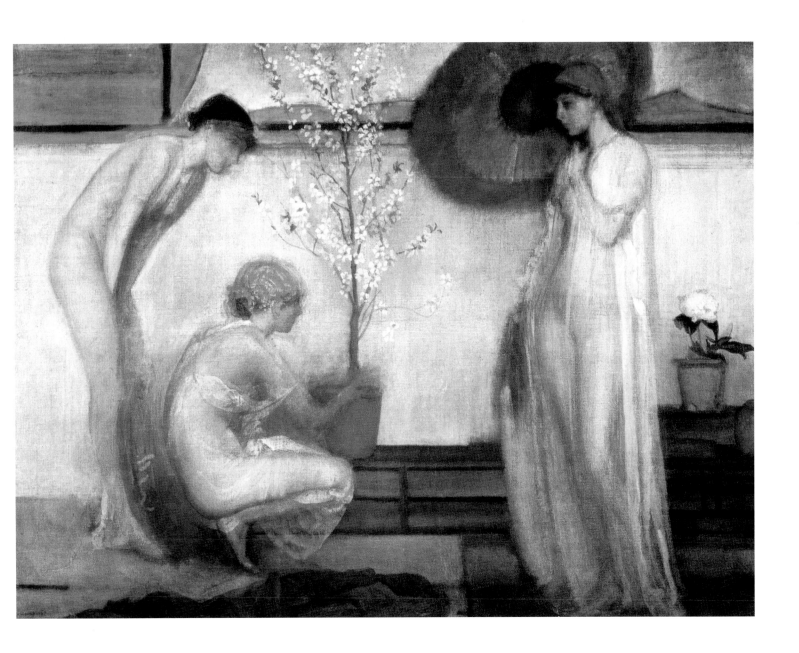

On November 25, 1878, the libel action opened in the Exchequer Chamber in Westminster, "in which Mr. James Abbott McNeill Whistler, an artist, seeks to recover damages against Mr. John Ruskin, the well-known author and art critic." The whole point of the case was to know whether an artist has the right to paint things as he sees them. As for Ruskin, who had been suffering from mental illness since 1870, he was a vain man who had already written disparagingly of Velasquez and Rembrandt. This was a good sign for Whistler, who thought he would be able to topple the great arbiter from his pedestal. The jury found for Whistler, but he was accorded one farthing as symbolic damages, and was not awarded costs. Criticism was unleashed against him. By now, Whistler was deep in debt, partly due to the costs of the trial, but also to his spendthrift lifestyle, and soon found his house papered with seizure orders and as was the custom in England in those days; bailiffs were moved into his home. On May 7, 1879, Whistler's debts were valued at £4640 while his assets amounted to only £1824; it was bankruptcy. *The White House* was sold on September 18, 1879. The artist was allowed to destroy his unfinished works prior to the liquidation sale. Other paintings were grouped into lots. The sale catalog lists such works as the studies for the *Six Projects*, a sketch of *Valparaiso*, a *Cremorne Gardens* painting and the *Young Girl in Blue: Portrait of Miss Eleanor Leyland*. Oscar Wilde was among the buyers. Wilde and Whistler had met some time before the trial.

In 1878, Wilde was twenty-four years old and still studying at Oxford. When he came to live in London he decided to become an art critic. The men had much in common - the same need to shine in society, the same lifestyle which led to their downfall, even the same taste for daring paradoxes. At first Whistler was flattered by the admiration of this brilliant young student who would spend hours in his studio. It was here that Wilde invented the character of Basil, a gifted painter who produced the portrait of a dissolute young man by the name of Dorian Gray.

33. *Nocturne in Blue and Silver: The Lagoon, Venice*. 1879-1880. 20 x 26 in. (51 x 66 cm). Museum of Fine Arts, Boston.

This enthusiastic friendship was to go badly wrong and would eventually become a tacit agreement of mutual aggression. The quarrel lasted for several years.
What had brought it about was when Whistler tested the artistic taste of his chronicler. Wilde had a shallow polish beneath which he hid a lack of reasoning and a lack of taste. Wilde was very good at adapting other people's ideas. Whistler, however, would not tolerate the presence in his studio of anyone who did not have an intelligent approach to his artistic views. Those who did not offer proof of this open mind were considered to be hostile.

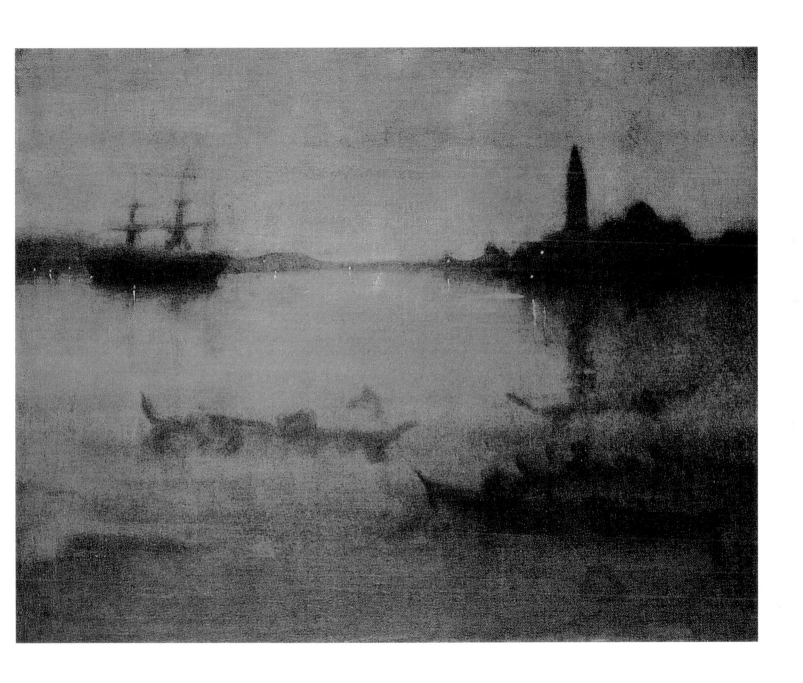

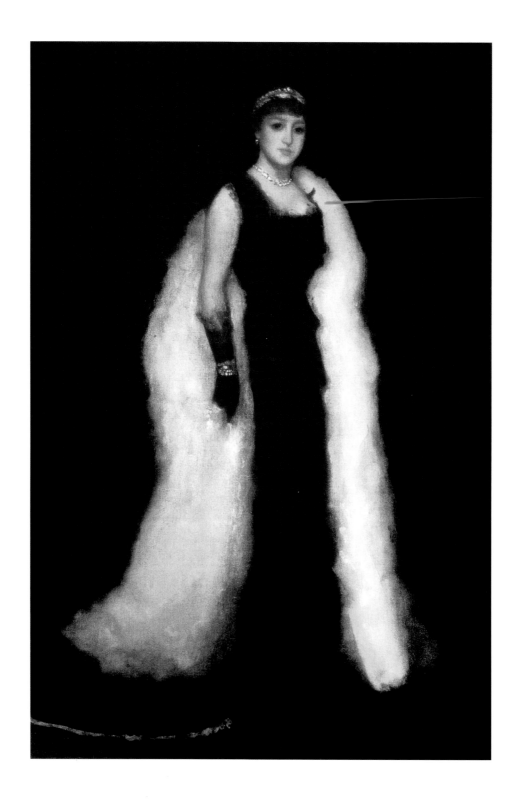

The Portraits

In 1881, the artist's fame began in America. They proclaimed their admiration for his ideas and his work. Private collections were started. *The Young Girl in White* was shown at The Metropolitan Museum of Art where it would stay for several years. He once again moved in society and appeared to be trying to attract attention to himself by every means. His enemies, renewing their attacks through the press, actually contributed to his revival. From now on, all his attackers would be treated to retorts in the form of letters to the press. The painting of Lady Meux is one of the best examples of Whistler's portraiture. It consists of a harmony of color, "an arrangement in white and black," a very powerful image set against a dark background. Lady Meux's black dress contrasts with the white fur edging of her coat. The richness of the tones is unequaled.

London had split into two factions, the Ruskin camp of ageing pre-Raphaelites and the Whistler camp whose followers included fashionable society. Whistler had many slavish admirers. The artist put his following to good use, taking two of his admirers to St. Ives during the winter of 1883-1884. His companions had to get up at six o'clock to prepare his canvases and mix his colors and this work helped him save valuable time. On the other hand, young painters learned far more from him than they could have done elsewhere. At the age of fifty, on November 21, 1884, Whistler became a member of the Society of British Artists. There was general surprise. The *Times* wrote, "We learn that the most independent and the least English of painters wants to enter a society of artists, and what a society! The one in Suffolk Street!" The Society of British Artists was founded in the early 19th century to fight the tyranny of the Royal Academy. The advent of Whistler gave hope of a renaissance. Whistler showed himself to be sensitive to this initial recognition, but did not realise the difficulty in which the institution found itself.

He thought it was time for a showdown with the Royal Academy. Claude Phillips wrote in the *Pall Mall Gazette* in July 1885, "The eccentric Mr. Whistler has gone to a neglected little gallery, the British Artists, which he will probably bring into fashion." That is, indeed, what happened; the public hastened to the exhibition. At the Winter Exhibition of 1885, Whistler exhibited the *Portrait of Mrs. Cassatt* and *Note in Violet and Green*, a nude study in pastels which caused a furore.

34. *Arrangement in Black, No. 5: Lady Meux.*
1881-1882.
76 x 51 in.
(194.2 x 130.2 cm).
Academy of Arts,
Honolulu, Hawaii.

35. *Little Nude Model Reading.*
6 x 7 1/8 in.
(16.8 x 17.8 cm).
Museum of Fine Arts,
Boston.

Whistler continued to keep himself in the public eye and give interviews. Whistler wanted his work to be better known abroad and made trips to Holland, Belgium and France, and wrote extensively about his concept of painting. Mrs. d'Oyly Carte, the owner of the Savoy Theatre in London, gave Whistler the opportunity of delivering his famous lecture and proved to be just as enthusiastic about it as the painter.

On the great evening of February 20, 1885, the hall was packed. The journalists were intrigued and wondered what they were about to hear. Whistler kept his discourse simple so as to allow no room for the critics to attack him on trivial grounds. As soon as the lecture began, the packed hall was won over, especially when he started talking about how London was transfigured at night.

A Mr. F. Day wrote, "I went to this lecture to amuse myself. I remained to admire." The public, by concentrating on his eccentricities, had forgotten that he had some very serious ideas about his art. Whistler reserved special treatment for his enemies the critics. For him, an art critic who is not an artist has no authority: he sees everything, except the essential.

In 1887, dissent increased within the Society of British Artists when the Prince of Wales honored the exhibition with a visit. On the day before the opening, Whistler stayed late in the hall to put the finishing touches to the decoration. Next morning, to everyone's horror, it was found that the doors and mantelpieces had been painted in yellow gold. The members protested and Whistler abandoned his unfinished work. The crisis came to a head in April 1888 when the conservative opposition made a move to oust him. Whistler and his supporters offered their resignations.

Marriage, Honors, *The Gentle Art of Making Enemies* (1888-1890)

The artist left for France to spend some time with firm friends who welcomed him warmly, especially Count Robert de Montesquiou, Théodore Duret and not forgetting Stéphane Mallarmé. Whistler had known Mallarmé in 1886, the year of the eighth and last Impressionist exhibition in Paris. On that day the two men laid the foundation for a firm and warm friendship. Mallarmé and Whistler had much in common; both were artists and the painter once confided in the poet, "You are alone in your art as I am in mine." They shared an ideal, the desire for perfection in their art. By the time they met they were already middle-aged. In 1888, Whistler was aged fifty-four and Mallarmé forty-one.

36. *Harmony in Pink and Grey: Portrait of Lady Meux*. 1881-1882. 75 x 35 5/8 in. (190.5 x 90.5 cm). The Frick Collection, New York.

37. *Arrangement in Black: The Lady in a Yellow Buskin, Portrait of Lady Archibald Campbell*. 1883-1884. 85 3/8 x 43 in. (213 x 109 cm). Philadelphia Museum of Art.

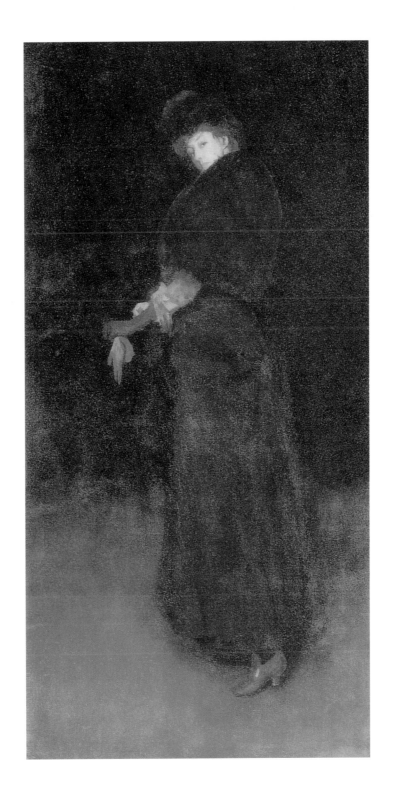

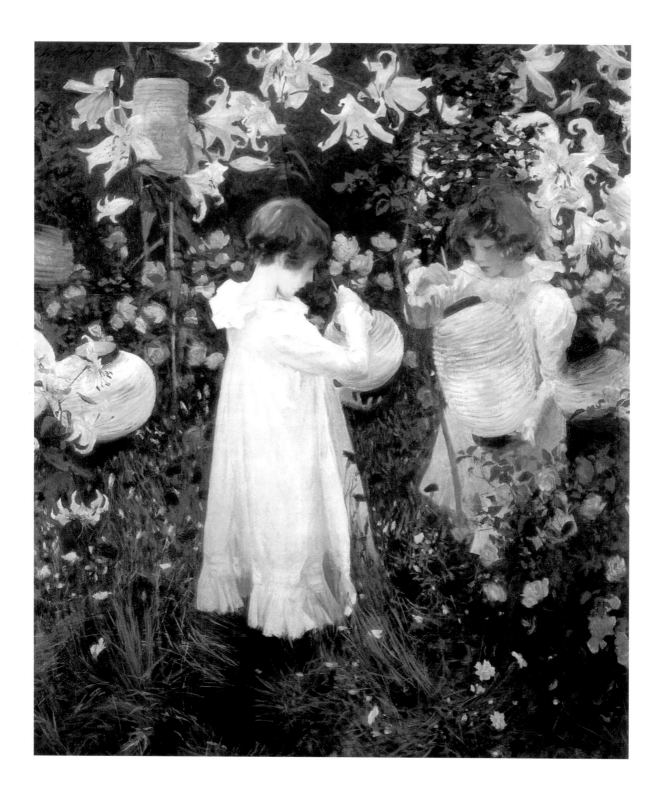

They remained attached to their values of dandyism, elitism and aristocracy.
On August 11, 1888, Whistler married Beatrix Godwin. The newlyweds left immediately for France where they honeymooned, traveling all over the country then staying in Paris. It was the start of a happy period. The couple lived a Bohemian lifestyle and Whistler was extremely attentive to his wife. The painter had done a great deal of work prior to this and for a while preferred to concentrate on family life. He received commissions but had neither the time nor the desire to fulfil them. Whistler's paintings were exhibited in New York.

At the urging of his friend, publisher William Heinemann, Whistler produced a book containing the wisdom he had accrued over the years. The work was called *The Gentle Art of Making Enemies* and contained all the documents produced in twenty-five years of combat. Whistler wanted to let the public judge for itself and worked at what he called "making history," that is to say, re-establishing the truth. The book was published in 1890. Indeed, the numerous documents, letters and catalogs presented chronologically prove the stupidity of some of his contemporaries.

On the other hand, the author's thoughts emerge clearly showing how ridiculous was most of the opposition he encountered during his career. The *Gentle Art of Making Enemies* crystallized Whistler's reputation as a man of letters of a rather cruel nature. The battle that Whistler was fighting was similar to that of the Impressionists in France, the official painters were members of the Royal Academy and were all-powerful.

On Saturday, November 21, 1891, the official letter asking to acquire *Portrait of the Artist's Mother* for France reached Whistler who felt himself to be a son of France now that this country "owned his mother." The purchase of the painting was widely publicized. In 1892, he was decorated with the Legion of Honor a distinction to which he attached considerable significance since it was the reward for thirty years of struggle.

In March, the Goupil Gallery in London exhibited Whistler's finest paintings, a true retrospective. This time, however, the press were almost unanimous in their praise. Whistler had finally become fashionable and would never lack for commissions again. Portraits were commissioned from him and his older works, previously ignored, were snapped up.

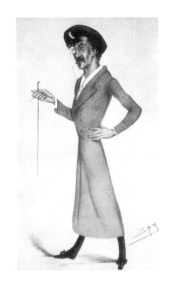

38. *Carnation, Lily, Lily Rose. John Singer Sargent*, 1885. Tate Gallery, London.

39. *A Symphony. Caricature of Whistler by "Spy" (Sir Leslie Ward)*, published in *Vanity Fair*, January 12, 1878.

40. ***Stormy Sunset, Venice***.
1889. 7 3/8 x 11 1/4 in.
(18.5 x 28.3 cm).
The Fogg Art Museum,
Harvard University.

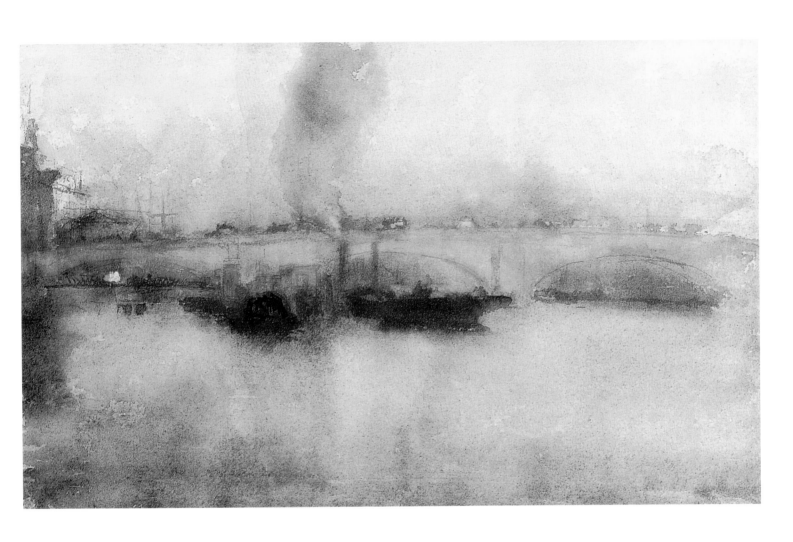

41. *London Bridge*. 1880 or 1890.
6 7/8 x 11 in. (17.5 x 27.8 cm).
Freer Gallery of Art,
Smithsonian Institution,
Washington.

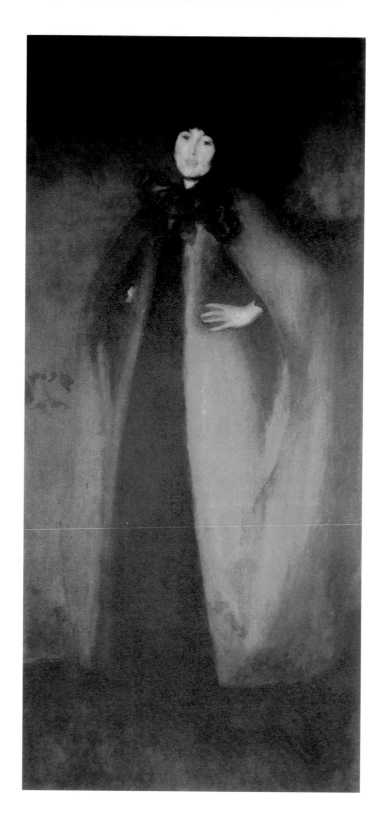

42. *Harmony in Red:*
Lamplight
(Mrs. Whistler). 1886.
74 3/5 x 35 in.
(189.8 x 88.9 cm).
Hunterian Art Gallery,
Glasgow.

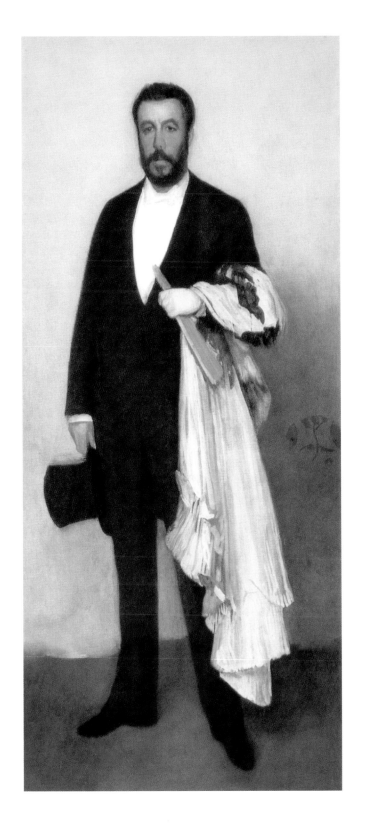

43. ***Arrangement in Flesh Color and Black: Portrait of Théodore Duret***. 1882-1884.
76 3/8 x 35 in.
(194 x 90.8 cm).
The Metropolitan Museum of Art, New York.

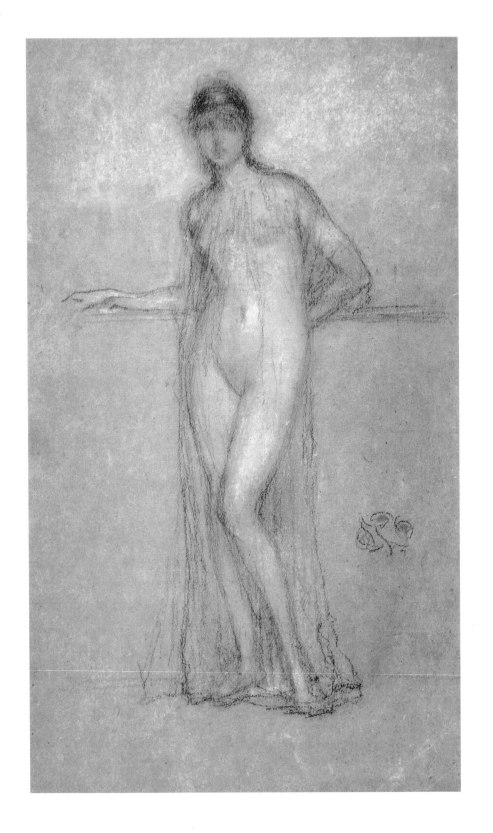

44. *The Arabian*. 1892.
 7 x 11 1/5 in.
 (18 x 28 cm).
 Hunterian Art Gallery,
 Glasgow.

45. *Blue and Violet*. 1889.
 10 1/5 x 5 7/8 in.
 (26 x 15.2 cm).
 Hunterian Art Gallery,
 Glasgow.

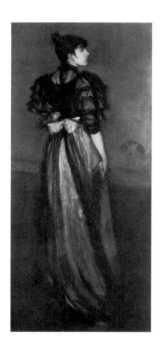

Private American collectors began buying. A price of $21,000 was paid for *Nocturne in Black and Gold: The Falling Rocket*. For the first time, Whistler was claimed as an American artist at the Chicago World's Fair; he was awarded a gold medal.

In September 1892, the painter produced a portrait of Mallarmé which fascinated anyone who knew the poet. He then undertook a series of portraits of A. J. Eddy, J. J. Cowan, Miss Williams and G. Kennedy. He painted the portraits of Mrs. Charles Whibley, *The Andalusian: Mother-of-Pearl and Silver, Pink and Gold, The Tulip: Miss Ethel Birnie Philip*, and Mrs. Walter Sickert, *Green and Violet*.

In 1894, he painted another self-portrait showing himself in a white linen vest. He did drawings of the streets of Paris, contributed to a revival of lithographic techniques and continued his experiments, working from morning until night to complete his commissions. But the painter was preoccupied with the suffering of Mrs. Whistler since their return to London. She had to enter a clinic while honors flowed in at a time when he least needed them. He was otherwise preoccupied and did not have the heart to work.

In December 1895, Mallarmé, having heard nothing from the Whistlers, wrote to them: "How are things with you? Around me, there is sometimes a fear that Mrs. Whistler will not recover her good health." Whistler was with his wife and he painted *Little Rose of Lyme Regis* and another portrait of his companion.

In the spring he left to install his wife in St. Jude's Cottage, Hampstead Heath, where she died on May 10, 1896. Whistler, in despair, destroyed a large number of pictures and he repainted two of his self-portraits in black where before they had shown him in a white suit. He went back to the wandering life, traveling extensively. In the summer of 1896, he visited Rochester, Canterbury, Honfleur, Calais and traveled through Holland. Then he returned to London.

Handsome Praise (1897-1903)

Through Robert de Montesquiou, Whistler met the portraitist Giovanni Boldini in Paris. The two men were wary though admiring of each other and were interested in each other's work. Whistler was persuaded to sit for a portrait, Montesquiou having played the role of public relations man.

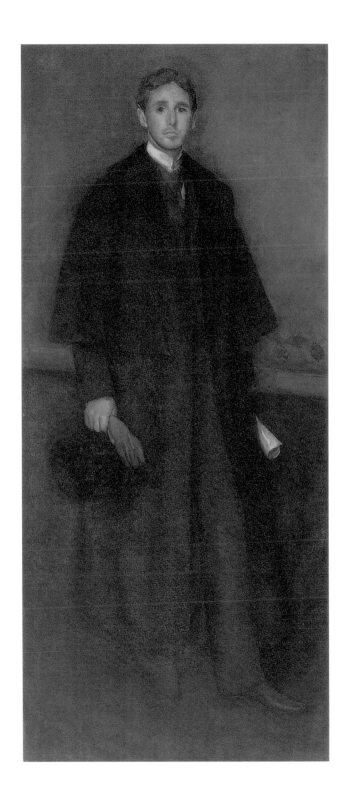

46. *Mother-of-Pearl and
 Silver: The Andalusian*.
 1888-1900.
 76 x 36 in.
 (191.5 x 89.8 cm).
 Harris Wittmore
 Collection, National
 Gallery of Art,
 Washington.

47. *Arrangement in Flesh
 Color and Brown:
 Portrait of Arthur
 J. Eddy*.
 1894. 82 x 36 in.
 (210.2 x 93.3 cm).
 Art Institute of Chicago.

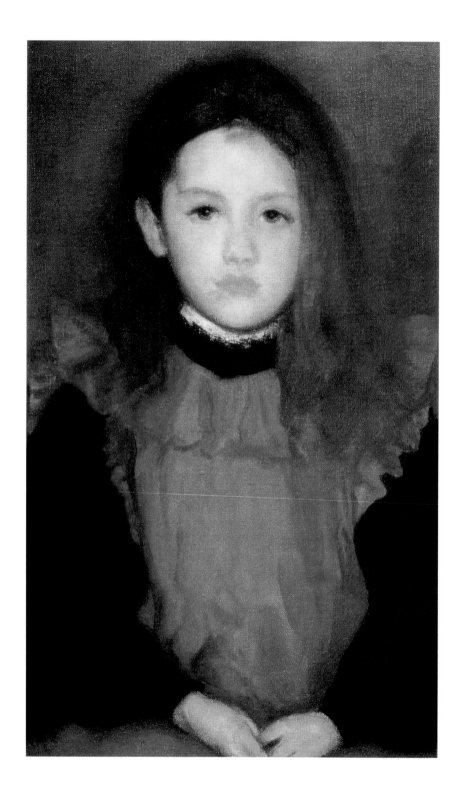

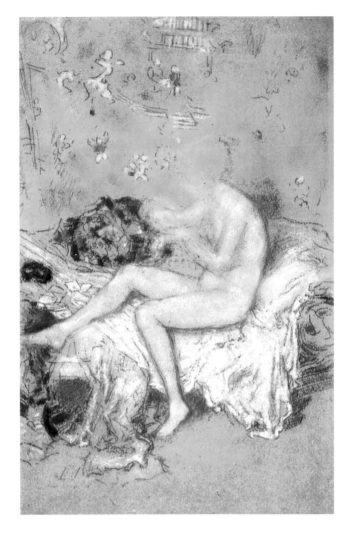

The painting was completed in a few sessions, Boldini, being as much of a virtuoso as his sitter, worked fast with great sureness of touch. The painting was a great success and was shown at the Universal Exposition of 1900. Whistler did not like it. James's difficult nature made him into an unusual and provocative character. Marcel Schwob reported that while visiting Alphonse Daudet's house at Champrosay, Whistler pretended ignorance by asking Francis Jourdain for explanations about the Impressionists. "There's someone called - Monet or Mounet, something like that, and Pissa... Pissora..." "Pissarro, Camille Pissaro," naively replied Schwob. "Yes, that must be it. Pizarro, that's it."

48. ***The Little Rose of Lyme Regis***. 1895.
20 x 12 in.
(50.8 x 31.1 cm).
Museum of Fine Arts,
Boston.

49. ***The Fortune Teller***.
1892.
Hunterian Art Gallery,
Glasgow.

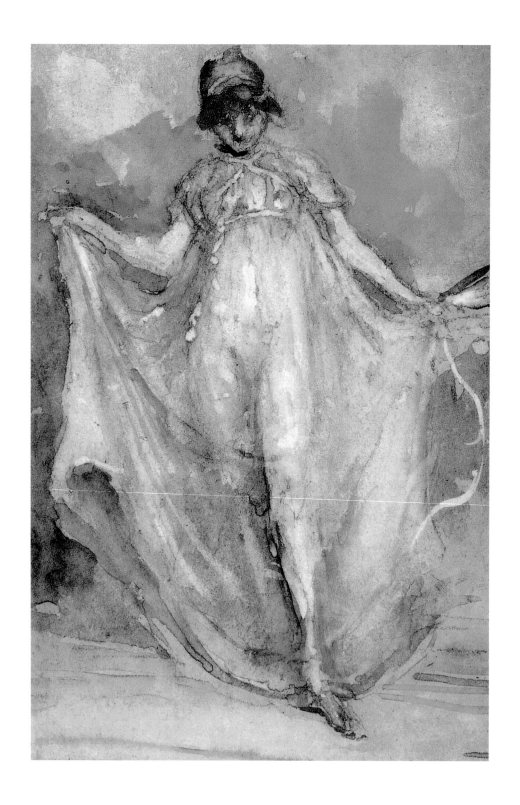

While shuttling between Paris and London, Whistler produced the commissioned portraits of Mr. and Mrs. Vanderbilt, Miss Kinsella, Miss Birnie Philip, Mr. Elwell and Geneviève Mallarmé. The painter began to think again about the middlemen who came between him and his clients and enriched themselves at his expense.

He therefore created the Butterfly Company at the end of 1897. He rented premises in London, near Manchester Square, which he decorated as a gallery. But since he was so often away, the store was closed for three-quarters of the time and there were no precise opening hours. Curious visitors streamed into his studio, causing a distraction, but he was not a man to permit himself to be incommoded in this way.

The two apartments in Paris were very bad for Whistler's health. The studio on the Rue Notre-Dame-des-Champs forced the painter to negotiate six flights of stairs although he had a weak heart. The Rue du Bac apartment was damp and Whistler caught cold easily. He had three attacks of influenza that winter. Weakened, rejecting the idea of death, Whistler launched himself into more and more projects.

In 1898, Whistler created a new, full-length self-portrait in which he shows himself wearing a heavy overcoat. The painting was shown at the 1900 exhibition under the title *Gold and Brown: Self-Portrait*. The painter also started a very important series of paintings of children, which were half-length. The painter entered a new phase in his career, the third after that of the *Nocturnes* and the full-length portraits. He organized an international exhibition which was open to all artists and was even prepared to allow members of the Royal Academy or any other such institution to belong to his association.

Whistler's fame was worldwide, and most of the members of the International Society of Sculptors, Painters and Gravers found it perfectly natural for him to assume the presidency. Many painters had been influenced by him and Whistlerisms had become popular expressions used in artistic circles (including those of the critics) to define painting. The International Society was inaugurated in a favorable climate with the support of the most promising artists, and Whistler took it very seriously. The first exhibition was held in London in opulent surroundings featuring the Society's official sèal designed by its president. It included works by Manet, Degas, Monet, Knopf, van Thoroop, Aman Jean, Fantin-Latour, von Stuck, Renoir, and Puvis de Chavannes.

50. *Green and Blue: The Dancer*. Watercolor, 10 x 6 in. (26.6 x 17.2 cm). Private Collection.

Whistler's contributions were *At the Piano, La Princesse du Pays de Porcelaine, Rosa Corder, Brown and Gold: The Philosopher, The Little Blue Bonnet*, and a self-portrait. Whistler played a major role in the recognition of the French painters in America by showing their work in the exhibitions of the International Society of Sculptors, Painters and Gravers. It came as a terrible shock when only a few hours later, he received a telegram from Mallarmé's daughter, "Oh, Dear Mr. Whistler, father died this morning." The artist began a new series of nudes on large canvases. He was particularly satisfied with the first one, entitled *Phryne the Superb: Builder of Temples*, which was exhibited at the International Society in 1901 and at the Paris Salon in 1902. Whistler intended to produce a series, which would include an Eve, an Odalisque, a Bathsheba and a Danaë. It can be seen how prolific the artist still was, despite his numerous preoccupations. Now that he was at the peak of his career, he found it easier to obtain the desired color harmony, "Finally, I am beginning to understand," he said.

In Paris, one of his models, Carmen Rossi, had the idea of starting a school of painting. She announced the creation of the Whistler Academy in the press, but Whistler himself soon corrected her by declaring that his "patroness" was funding a studio at which he undertook to teach his method of painting and to design the premises. The school finally took the name of the Carmen Academy. The students flocked to it from many countries. In 1900, the master was sick and was forced to end the year recovering in the South of France. Consequently, students gradually began to drift away from the Academy.

For the Universal Exposition in Paris, the artist, who was then aged seventy, exhibited *The Andalusian, Harmony in Black: Mrs. Charles Whibley, Self-Portrait in Black and Gold, The Little Girl in White* and some etchings in the American section. He was awarded a Grand Prix for engraving and a Grand Prix for painting. He was now quite wealthy. That summer, it was very hot in London in July. Whistler suffered from the heat but fooled his entourage by seeming to be in good health.
In October 1900, Whistler's health deteriorated noticeably and he quite often began to feel tired for no reason.

After another series of trips, Whistler returned to London in 1901 and worked very discreetly. When Rodin came to London and the whole town was bestowing honors upon him, the sculptor visited with Whistler. On June 17, Charles L. Freer, the philanthropist, came to London and took a trip to Holland with the painter.

51. ***The Jade Necklace***.
1896-1900.
20 x 12 in.
(51 x 31.7 cm).
Hunterian Art Gallery,
Glasgow.

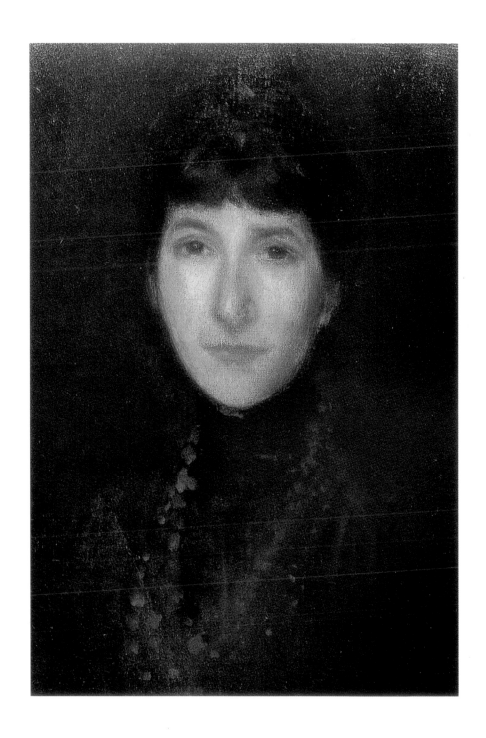

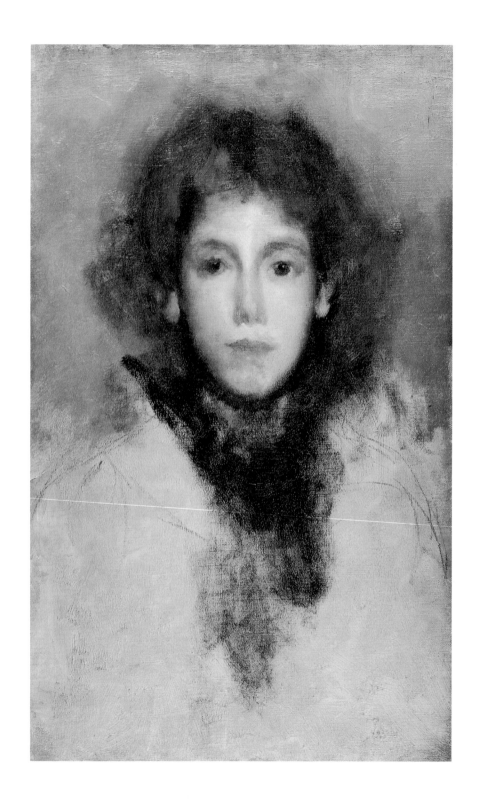

The artist profoundly influenced Freer's taste when it came to other paintings and oriental art objects. In 1900, Freer's tastes had developed considerably. He was no longer interested in exclusively American artists, but concentrated on Whistler's work until his death. Freer spent a quarter of his fortune on American art and most of this money was devoted to his Whistler collection.

The painter fell ill and upon returning to London, he came under doctor's orders, being forbidden to climb stairs. On bad days, he could not walk and remained in bed. When he found the strength, he asked for a model. The painter sorted out what was sent to him from his Paris studio and destroyed whatever displeased him. He no longer attended the meetings of the International Society of Painters, Sculptors and Gravers due to his poor health but demanded detailed reports. The United States paid unprecedented homage to a man it claimed as its greatest artist. Artists claimed to have been influenced by him, museums boasted of having acquired his paintings. Almost all of Whistler's work left Europe.

In the spring of 1903, Whistler's friends believed that the end was near as his naps became more frequent as his heart weakened. On July 1, the artist stayed in bed, his expression vague. On Friday, July 17, 1903, he had a last and fatal attack after lunch; a legendary figure had disappeared. The burial took place on July 23. The funeral service was held in the Old Chelsea parish church which Whistler knew well. There were few mourners, his immediate family and a few friends.

In the *Times*, Andrew MacLaren Young had written about Whistler's paintings of the Thames in 1864: "If Velasquez had painted our river, this is the style in which he would have done so." Velasquez had indeed always been a source of inspiration for Whistler. He also fell under the influence of Ingres whose student he would have liked to have been, as well as that of Rembrandt and Vermeer, who can be felt everywhere in the portraits he made at the end of his life. Then there were the influences of the Old Masters as well as of his contemporaries - Courbet and some of the Impressionists - the orientalising influence of the Japanese wood-block prints. The artist was able to ingest all of these inspirations and create a unique style.

Although the stamp of the Old Masters is to be found in his work, his painting is profoundly modern and original. All his innovations were met with incomprehension and disavowal on the part of his contemporaries.

52. *Little Juniper Bud: Lizzie Willis*. 1896-1897. 20 x 12 in. (51.5 x 31.3 cm). Hunterian Art Gallery, Glasgow.

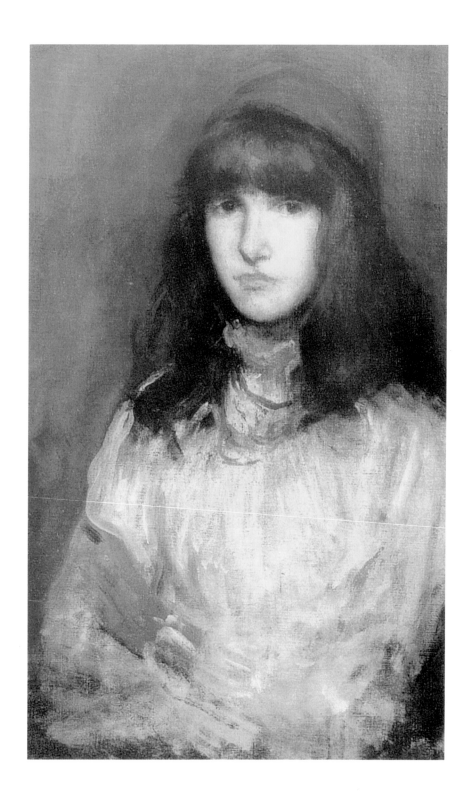

Yet it is above all in the paintings showing storefronts, which was Whistler's favorite theme in the last twenty years of his life, that he was so prophetically modern.

He reached the end of his artistic adventure bringing his innovations to fruition. Great subjects, great modernists, and personal choices from the beginning of his career would remain powerful until the end of his life, their richness and content were so vast. The experience of the *Nocturnes* is an absolute in itself, begun in Valparaiso and reaching maturity in London beside the Thames. This is the way in which all of Whistler's artistic experiences evolved.

The painter has left us a number of portraits which are absolute masterpieces. He is a witness of the times and the dandyism which Baudelaire loved so much, yet at the same time, his portraits are original in the way in which they are created. Whistler was able to make tangible contact between the subject and the artist and to transform this creative stage through his vibrant work in which one is seized both by the painter's artistic emotion and the interior nature of the subject. It is not a fixed image but something like a frame from a movie. Like his fellow painters of the Impressionist generation, Whistler never failed to enthusiastically support the great poets and writers. He influenced them, and they have left their traces in his own work.

On the other hand, he was very good at translating his painting into literary terms. In part constrained and forced by the critics and the public, he was forced to defend himself to try and make them understand his aesthetic message.

In any case, he always received adulation from writers. It is this that many artists lack, the ability to express their art, the link between the image and the word. With Mallarmé the artistic link was firm. Marcel Proust was a discreet but convinced admirer. Proust's empathy and surprising understanding for Whistler's painting is manifested in *Remembrance of Things Past (A la Recherche du Temps Perdu)*.

Rodin would succeed Whistler as president of the International Society of Painters, Sculptors and Gravers. He spoke of Whistler's work in the following terms: "Whistler's art will never become outdated; it will only gain in importance because one of his strengths is energy, another delicacy, but above all it is the scale of his drawing." In 1905, the International Society of Painters, Sculptors and Gravers paid homage to the painter by assembling a magnificent collection of his works in a retrospective exhibition.

53. *The Little Red Glove*.
1896-1902.
20 x 12 in.
(51.3 x 31.5 cm).
Freer Gallery of Art,
Smithsonian
Institution,
Washington.

54. *Blue and Coral: The Little Blue Bonnet*.
1898.
32 x 27 in.
(81.2 x 68.5 cm).

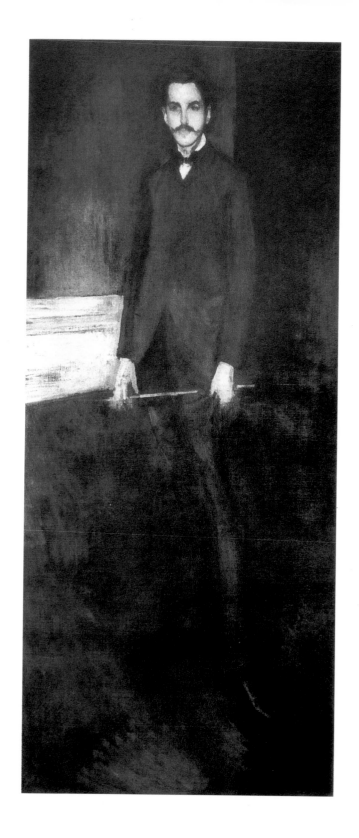

55. *Portrait of George
W. Vanderbilt.*
1897-1903.
80 x 37 in.
(208.6 x 91.1 cm).
National Gallery of
Art, Washington.

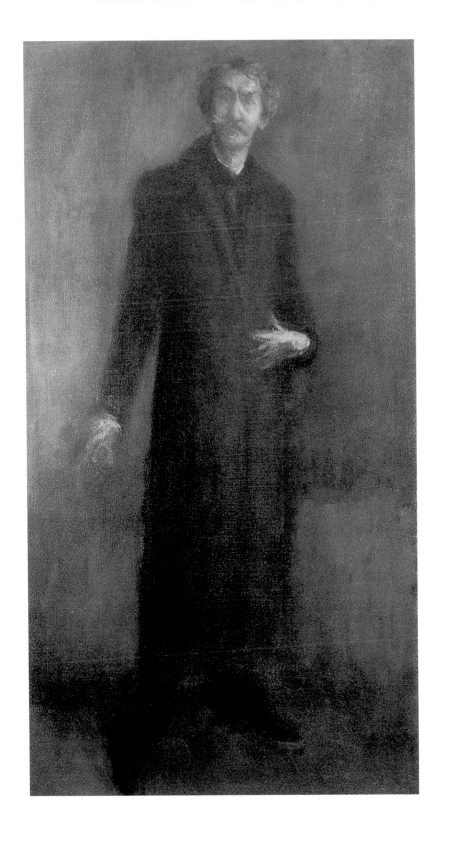

56. *Brown and Gold*.
1895-1900.
38 1/8 x 20 in.
(95.8 x 51.5 cm).
Hunterian Art Gallery,
Glasgow.

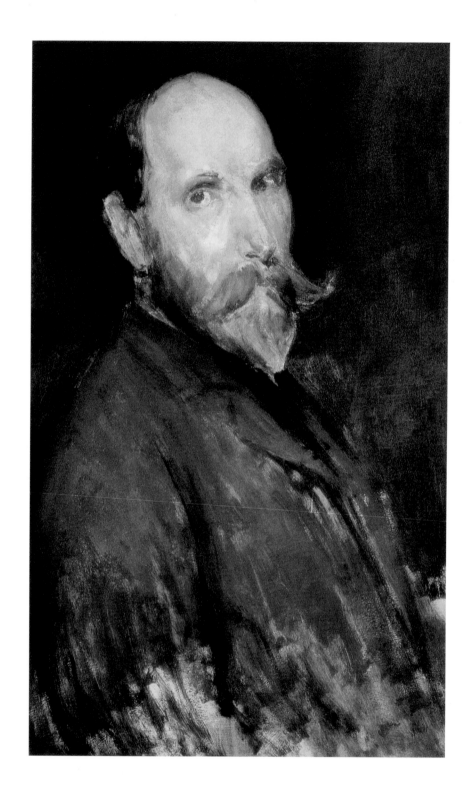

BIOGRAPHY

1834	July 10, born in Lowell, Massachusetts, christened James Abbott Whistler.
1842	Major Whistler, James's father, settles in St. Petersburg, Russia.
1844	Mrs. Whistler and the children join Major Whistler.
1845	J. W. takes drawing lessons at the Imperial Academy.
1847	J. W. spends most of his time in England with his half-sister, the wife of the well-known engraver Seymour Haden.
1849	Major Whistler dies. The family returns to the United States.
1851-1852	J. W. enters West Point Military Academy from which he is discharged.
1853-1854	Various apprenticeships, first in a locomotive factory, then at the U.S. Coastal Geodetic Survey in Washington. Resigns in 1855.
1855	J. W. goes to Paris in November. Universal Exposition in Paris. Courbet Exhibition.
1856	In June, Whistler enters the Académie Gleyre.
1858	Produces his first etchings in London, while staying with Seymour Haden. Visits Amsterdam, then the East. Returns to Paris and meets Fantin-Latour and Manet. Starts working on his canvas, *At the Piano*.
1859	*At the Piano* is rejected by the Salon. Exhibits a few etchings in England. Exhibits *At the Piano* in François Bonvin's studio. Goes to live in London.
1860	*At the Piano* is exhibited at the Royal Academy, where it is well-received by the critics and bought by the artist John Philip. Starts the painting entitled *Wapping* and meets Jo, his model and mistress.
1861	Landscape painting in Brittany. Meets Degas.
1862	Takes a house in Chelsea where me meets the pre-Raphaelites, whose members included Rossetti, Swinburne, William Morris and Burne-Jones. Exhibits *La Fille Blanche* at the Salon des Refusés in Paris. Wins a gold medal in Holland for his etchings.
1864	Under the influence of Japanese art, paints *Rose and Silver: La Princesse du Pays de Porcelaine*. J. W. poses for a group portrait by Fantin-Latour entitled *Homage to Delacroix*. Paints *The Little White Girl* and *The Gold Screen*. First use of the butterfly signature.

57. ***Private of Charles L. Freer***. 1902-1903. 28 3/8 x 23 in. (51.8 x 31.7 cm). Freer Gallery of Art, Smithsonian Institution, Washington.

58. ***Photograph of Whistler***. 1885-1886. University Library, Glasgow.

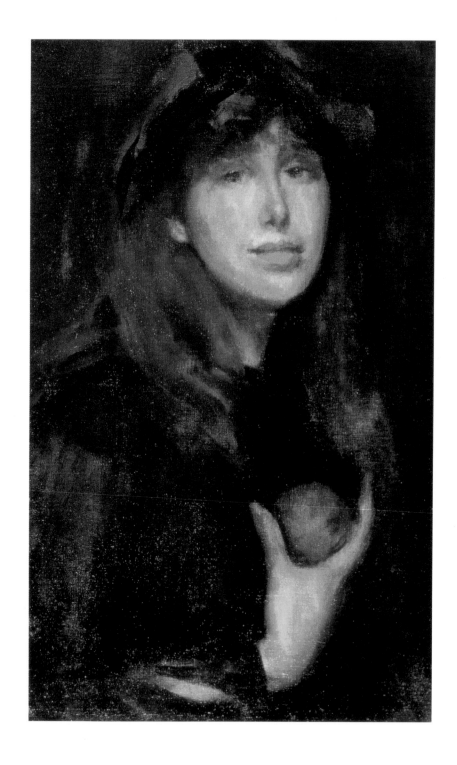

1865	Exhibits received badly at the Royal Academy in London. Stays in Trouville, France with Courbet and Jo.
1866	Visits Chile, paints landscapes of Valparaiso, first nighttime landscapes. Separation from Jo.
1867	Exhibits *At the Piano* and *Thames in Ice* at the Salon as well as at the Royal Academy and the Universal Exposition in Paris. Works on *Six Projects*, heavily influenced by Japanese art.
1868	First meeting with the philanthropist F. Leyland.
1871	Publication of the Thames series. Paints *Arrangement in Gray and Black: The Artist's Mother*, reluctantly accepted by the Royal Academy.
1872	For the first time, uses the word "Nocturne" and other terms borrowed from the vocabulary of music.
1874	First one-man show at the Flemish Gallery in London. Meets Maud Franklin, model and companion.
1875	Portraits and *Nocturnes*.
1876	Starts work decorating the Peacock Room for F. R. Leyland, completed in 1877.
1877	*The Falling Rocket* is exhibited at the newly-opened Grosvenor Gallery. John Ruskin makes an acerbic remark about it. Whistler sues him and wins but is ruined. Publication of Whistler v. Ruskin.
1879	Leaves for Venice with Maud Franklin. Brings back a series of etchings and pastels.
1880	Returns to London at the end of the year. Exhibits his series of etchings which are poorly received by the critics.
1881	Death of J. W.'s mother. Meets Oscar Wilde. Exhibits pastels of Venice.
1882	Several portraits.

59. *Dorothy Seton, a Daughter of Eve*. 1903. 20 x 12 in. (51.7 x 31.8 cm). Hunterian Art Gallery, Glasgow.

1883	Exhibits at the Fine Art Society. Wins a medal at the Salon de Paris for *The Artist's Mother*.
1884	Major one-man show of watercolors at the Dowdeswell Gallery in London. J. W. is elected member of the Royal Society of British Artists.
1885	Delivers his *Ten O'Clock* Lecture for the first time in London. Trips to Belgium, Holland and Dieppe, France.
1886	Elected President of the Society of British Artists which, the following year, becomes the Royal Society.
1888	Marries Beatrix Godwin. Mr. and Mrs. Whistler spend the summer in France.
1889	Receives the French Legion of Honor as well as the Gold Medal at the Exhibition in Amsterdam.
1890	Publication of *The Gentle Art of Making Enemies*. Meeting with Charles Freer, who becomes the greatest collector of works by Whistler.
1891	*The Artist's Mother* is bought by the Museum of Luxembourg. J. W. begins a painting of Count Robert de Montesquiou.

60. *Whistler*.
 Portrait by Giovanni
 Boldini. Brooklyn
 Museum, New York.

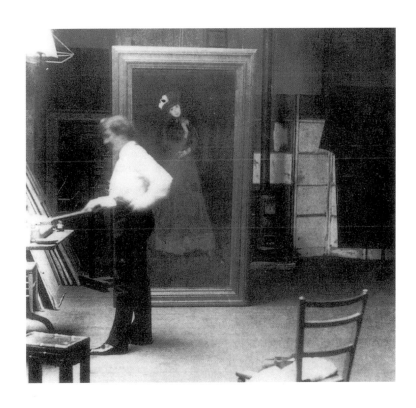

1892	Buys a house on the Rue du Bac in Paris and opens a studio on the Rue Notre-Dame-des-Champs.
1893-1895	Produces several portraits, including one of Mallarmé, for his collection Verse and Prose. Lawsuit against Sir William Eden.
1895	Moves to Lyme Regis, Dorset, England, with his wife who is suffering from cancer. Works on his second portrait of the Count de Montesquiou.
1896	Whistler's wife dies.
1898	Becomes President of the International Society of Sculptors, Painters and Gravers. Mallarmé dies. Spends the fall in Paris and opens an art school with Carmen Rossi.
1900	Wins the Grand Prix in Painting and the Prize for Engraving at the Universal Exposition in Paris. Trip to the Mediterranean.
1902	J. W. falls ill. He gives up his Paris workshop and home. Starts a portrait of Charles Freer which he will never finish.
1903	Whistler dies of a heart attack in London.

61. *Whistler painting in his studio on Fulham Road.*

LIST OF ILLUSTRATIONS